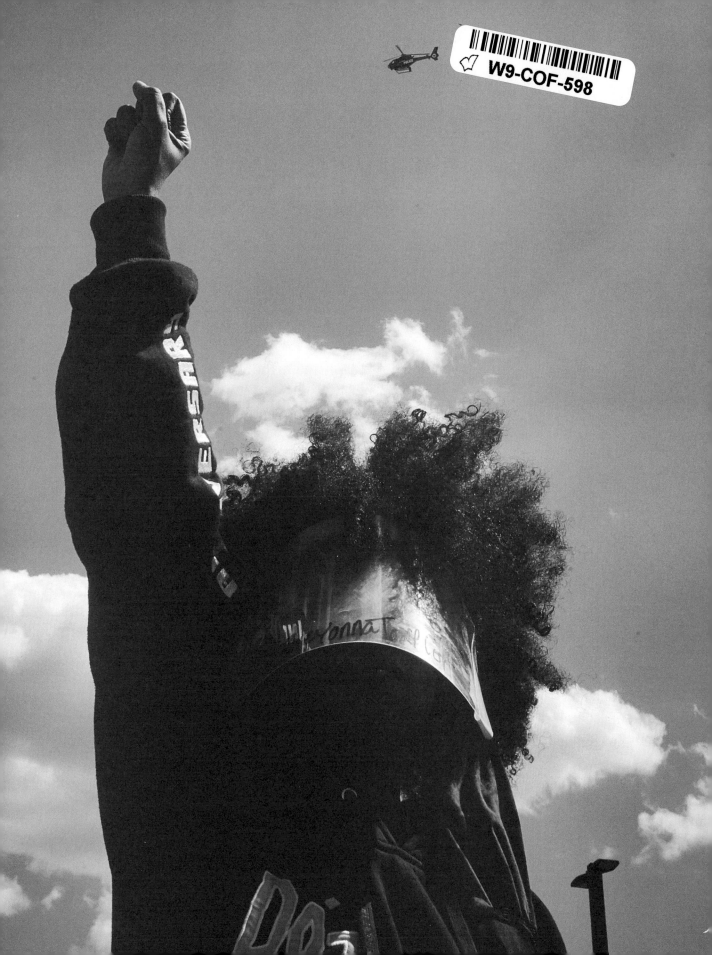

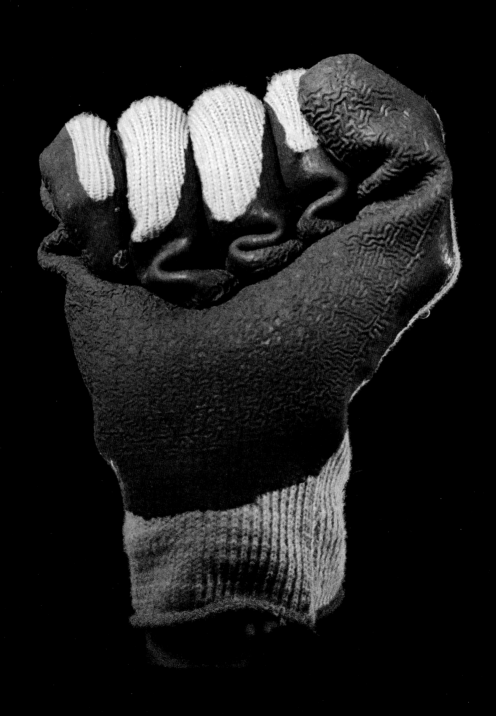

NO JUSTICE, NO PEACE

FROM THE CIVIL RIGHTS MOVEMENT TO BLACK LIVES MATTER

DEVIN ALLEN

WITH IMAGES BY
GORDON PARKS
FOREWORD BY
JAMEL SHABAZZ

LEGACY
LIT

New York Boston

See pages 175–176 for complete list of credits and permissions

Cover design by Shreya Gupta
Cover photo by Devin Allen

Designed by Diahann Sturge

Legacy Lit, an imprint of Grand Central Publishing
Hachette Book Group
1290 Avenue of the Americas, New York, NY 10104
LegacyLitBooks.com
Twitter.com/LegacyLitBooks
Instagram.com/LegacyLitBooks

First edition: October 2022

Grand Central Publishing is a division of Hachette Book Group, Inc. The Legacy Lit and Grand Central Publishing names and logos are trademarks of Hachette Book Group, Inc.

The publisher is not responsible for websites (or their content) that are not owned by the publisher.

The Hachette Speakers Bureau provides a wide range of authors for speaking events. To find out more, go to www.hachettespeakersbureau.com or call (866) 376-6591.

The following photographs by Gordon Parks are courtesy of and copyright © The Gordon Parks Foundation: pages x–xi: Untitled, Harlem, New York, 1963; page xii: Untitled, Harlem, New York, 1963; page xiii: (top) Muhammad Speaks, Chicago, Illinois, 1963; (bottom) Untitled, Harlem, New York, 1963; page xiv: (top) Untitled, New York, 1963; (bottom) Protest Against Police Brutality, New York, New York, 1963; page xv: Untitled, Watts, California, 1967; page 2: Untitled, Watts, California, 1967; page 14: Untitled, New York, 1963; page 38: Malcolm X Holding Up Black Muslim Newspaper, Chicago, Illinois, 1963; page 68: Martin Luther King, Jr., Washington, D.C., 1963.

Library of Congress Cataloging-in-Publication Data has been applied for.

ISBNs: 978-0-3069-2590-0 (hardcover); 978-0-3069-2591-7 (ebook)

Printed in China

IM

10 9 8 7 6 5 4 3 2 1

This is for my uncle Jody, my brother, my friend, my protector. Thank you for always having my back. Continue to watch over me.
I love you! Rest in Peace.

FOREWORD

Jamel Shabazz

"I picked up a camera because it was my choice of weapons against what I hated most about the universe: racism, intolerance, poverty."
—Gordon Parks

During Ronald Reagan's presidency, from 1981 to 1989, the United States prison population doubled. Black men, at the time, made up 13.4 percent of the total US population and 40 percent of those incarcerated. Social scientists concluded that one in three Black men would end up in prison during their lifetime. In the 1980s, many urban cities saw a drastic increase in their homicide rates, averaging close to three hundred a year. Devin Allen, a native son of West Baltimore born in the '80s, came of age during the height of the crack and AIDS epidemics. The odds were stacked against him in this environment. By his teens, he had already witnessed his close friends fall victim to incarceration and death. This compounding trauma would be far too much for any young man to bear, and for many, it certainly is. Fortunately for Devin, he had strong familial support, which kept him grounded until he discovered his calling in the field of photography. Photography set him on a path of self-discovery and offered Devin the ability to channel his passion and rightful disdain toward the world into art. Now he emerges as a true student of Gordon Parks, the famed twentieth-century Black photographer who used the camera as a weapon to fight against injustice.

I was blessed to meet Devin at the National Gallery of Art in Washington, DC, in 2018, at an opening for an exhibition featuring the work of Gordon Parks, titled *Gordon Parks: The New Tide, Early Work 1940–1950*. Devin and I conversed about his incredible life and journey.

I was most impressed by Devin's commitment to teaching photography to the next generation. He offers his students the same path that changed his own life. Gordon Parks said, in his many messages to young people, that in order to succeed, you must have desire and courage. Not only does Devin possess those two qualities, but he also has a beautiful soul and a powerful third eye that allows him to see and capture the essence of his people.

As a photographer myself, I am most captivated by his insightful images of protests. Amidst the images of rage and sorrow that he captures is a celebration of life. The pages of *No Justice, No Peace: From the Civil Rights Movement to Black Lives Matter* chronicle decades of protests in the United States. Devin's black-and-white images bear similarities to Parks's photos of Black people gathering in the name of progress. Through the lens of his camera, and with supporting essays and poems from talented writers, Devin asks us to consider how much racial progress has truly been made. He assures us that our communities will continue to rise higher, chant louder, and usher in another new tide of change.

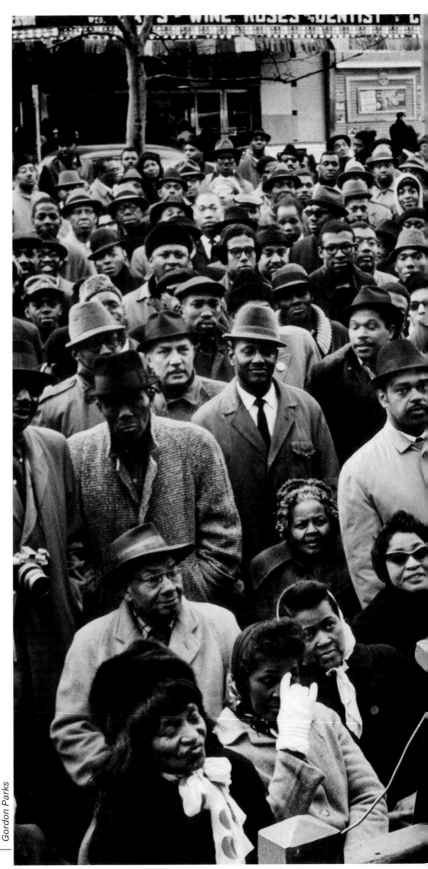

Gordon Parks

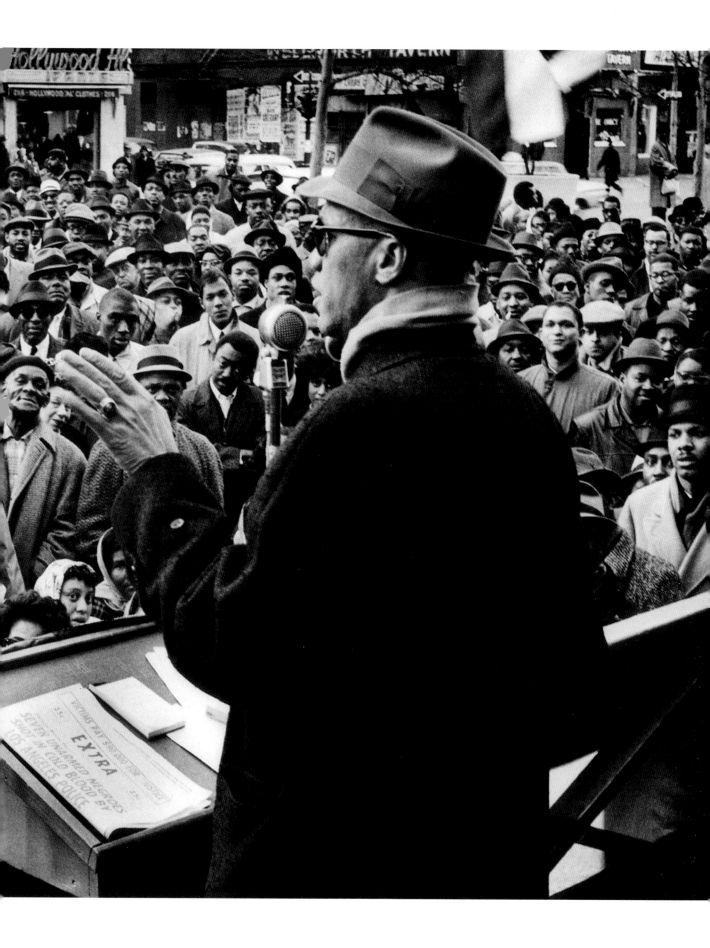

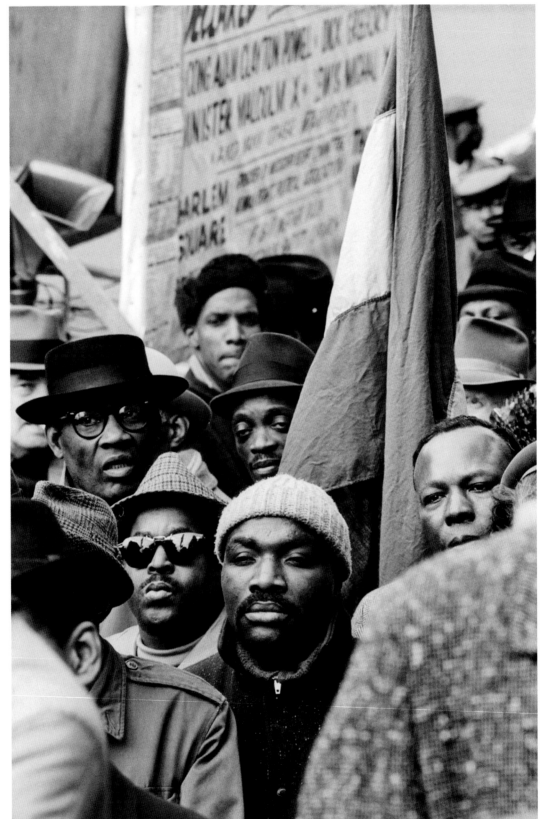

Gordon Parks

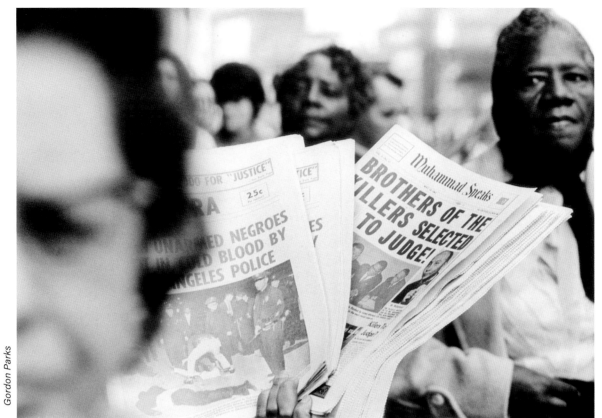

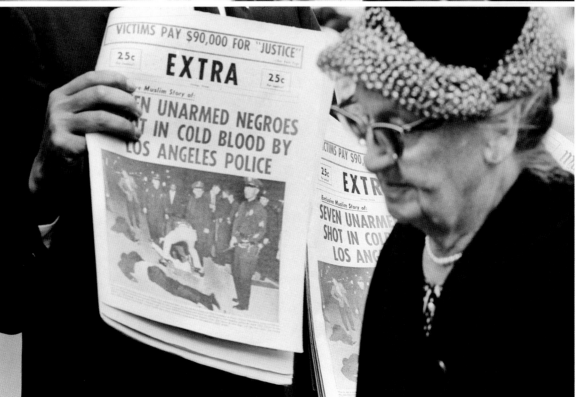

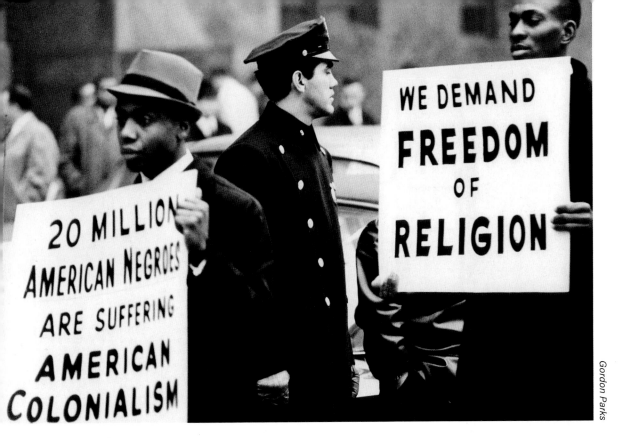

Gordon Parks

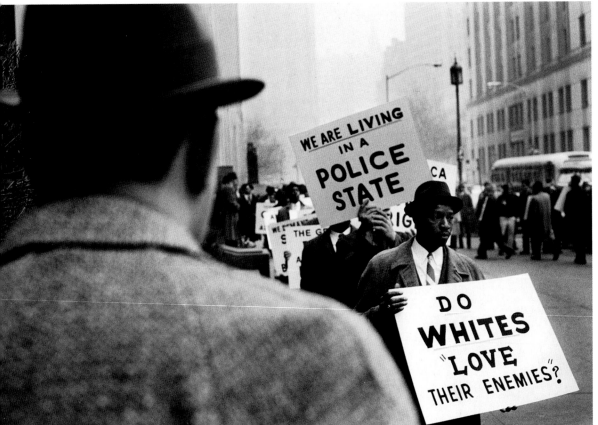

Gordon Parks

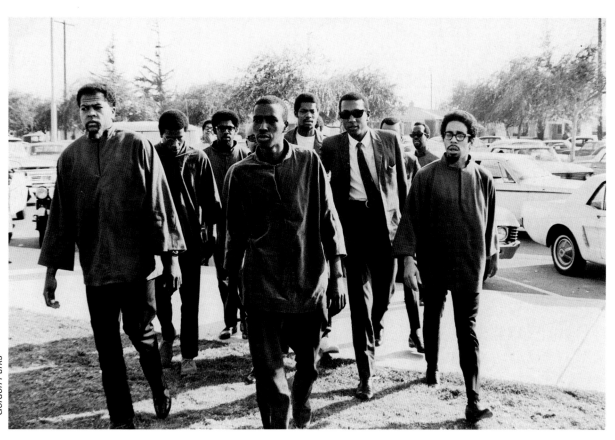

Gordon Parks

INTRODUCTION: BECAUSE I AM BLACK

While compiling this book, I thought about my experience growing up in Baltimore, surrounded by my family's love, which carefully shielded me from what went on beyond my porch. I eventually would find out what was on the other side of that shield. After losing one friend to the system and one to gun violence, I gained an intimate understanding of what the streets of Baltimore held in store for me.

I started to see guns, prison, and drugs take friends and community members. The more I saw, the more it changed who I was as a person. That once energetic and naive kid was gone, and my childhood as I knew it was over—but a new journey was right around the corner.

In 2009, when I was twenty-one, my life changed. I remember holding my daughter for the first time, and it gave me a feeling I honestly can't fully put into words except to say that I felt like I had a purpose and a reason to live. I realized that I needed to survive and thrive for *her*.

With so much loss around me in Baltimore, I experienced a transformation through finding art; it helped me develop a sense of identity. Around 2010, things changed when I started to host open mics in the city with my friend Josh. I wasn't an artist before he introduced me to the scene, much less a poet, but we knew we could get people in the room for a good time. I started photographing the poetry nights with an old camera Josh owned, but then fell in love with the craft and my community through the lens of a camera. The next thing I knew, I was running around Baltimore, capturing any- and everything. My friend didn't see his camera for weeks at a time while I shot portraiture for families, test shots for aspiring models, and music videos for my rapper friends.

To understand my place in the art world, I knew I had to look to the legends of the craft. I started from square one—Google. Gordon

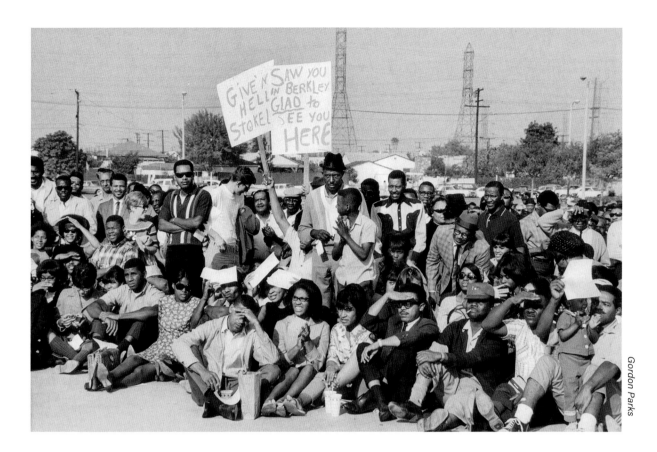

Gordon Parks

Parks was the first person listed in a search for "Famous Black Photographers." His photos of the mid-twentieth century reflected both the intimate struggle of Black people in America and the unwavering hope our people have to this day. Black people have always impacted the world around them through their art. There were so many greats: Gil Scott-Heron, Billie Holiday, Nina Simone, and my grandmother.

In 2013, I got my first camera because of her. Grandma recognized my growing passion and bought me a camera with her Best Buy credit on the line. I knew from her selfless investment that I had to take photography seriously.

I spent hours on YouTube and in bookstores, flipping through Parks's photos and obsessively reading everything about his life. He once said,

"I picked up a camera because it was my choice of weapons against what I hated most about the universe: racism, intolerance, poverty." I didn't know it at the time, but the camera would also be my choice of weapon.

In 2014, Mike Brown was killed by police officer Darren Wilson in Ferguson, Missouri.

I was not shocked at all.

The truth is that my life experiences—regular, spontaneous encounters with law enforcement—have become normalized in my community. I had to learn early on how to deal with law enforcement—how to avoid them, how to talk to them when needed—and it seemed naturally put upon me simply because I am Black.

On a regular day in 2011, I was home when I heard a news story about a police shooting at a

club in downtown Baltimore. It sounded like something out of a movie, as the journalist reported that a plainclothes officer had gotten into a fight with a group of guys and recklessly opened fire into the crowd. On-duty police officers, unaware he was a cop, fired back and killed Officer William Torbit Jr., along with a twenty-two-year-old civilian, Sean Gamble. My friend from high school.

My heart dropped. I called around to my friends, hoping the news about his death wasn't true. I'd lost plenty of friends by that time—but this was different. Gut-wrenching. Gamble was one of the most cheerful people I'd ever met. Always smiling, singing, and dancing. Losing him in that manner was hard to digest.

These are the moments in life when you feel powerless. Someone told me about a protest against the police's murder of Gamble, but I didn't see the point in going. I had no voice, no power.

Three years after Sean Gamble was killed, I once again stood in my home, watching the news of Michael Brown's story and the protests breaking out in Ferguson pour out onto my Twitter feed. This time, when I saw a flyer online about a solidarity march in my city, I grabbed my jean jacket, jumped in my 2007 Honda Accord, and sped to city hall to join.

I arrived there to hundreds of people chanting, "Hands up, don't shoot" and "No justice, no peace, no racist police." The energy swelled with every refrain as the wind carried their demand for justice down blocks and blocks. I started taking pictures, and with every snap of my camera shutter, every shot got sharper. I felt a fragile sense of hope, marching through the streets with my arms locked with others'. The gentle night breeze whispered of change, and in that moment, I started to understand Gordon Parks as an artist. His inspiration was my guide. Photography no longer felt like a hobby. This camera, three pounds at best, was heavy with history. When I got home, I uploaded images and scrolled through them and thought of Gordon Parks's words: "I feel it is the heart, not the eye, that should determine the content of the photograph. What the eye sees is its own. What the heart can perceive is a very different matter."

The following year, on April 19, 2015, Freddie Gray passed away from injuries inflicted by Baltimore City Police just seven days earlier. As the video of him getting injured went viral around the city and online, the protest grew in numbers. First, a couple of hundred people at the hospital where Freddie died. Then about a thousand people at Gilmor Homes, where Freddie had lived. The air was thick with rage. Armed with my camera and the crowd's demand for justice, we marched toward city hall.

The number of protesters doubled as we marched through downtown Baltimore. Friends, family, and organizers worked together to keep everyone safe. My homeboy Taz watched my back as I backpedaled and climbed street signs to get my shots. Loud chants came from every direction—"All night, all day, we are going to fight for Freddie Gray"—until we arrived at city hall. I held my camera tight in frustration as I listened to community leaders and Freddie's family and friends speak of the injustice our community suffered. A few protesters broke away from the larger group and were running back toward Oriole Park.

I followed the group as they sprinted through the streets, and when I reached the front of the line, I saw protesters about to clash with police, with only a little metal barrier separating them.

Right across the street were a bunch of sports bars with agitated white baseball fans dressed in patriotic-looking jerseys and hats. Oriole Park staff members were forced to close stadium doors to fans because of the protest. The fans threw food at protesters, calling us monkeys and niggers. For a split second, I could have sworn I had been transported back in time to 1960.

The story unfolded as we have seen time and time again: state troopers arrived, armed with batons and shields. They unleashed pepper spray on our side of the street, where protesters were quick to pour milk into upturned eyes. Protesters who ran were slammed to the ground and arrested. I was able to get away because I was taking pictures just far enough from the heart of the chaos.

I took a short break to send images from my camera to my phone. I posted them on social media in real time to stay ahead of the media outlets reporting on the protests; this would soon become my process throughout the weeks to come.

Before long, *Time* magazine called, requesting to interview me about my work and the Baltimore Uprising. Many outlets and publications did the same, and my network and social media platform expanded. What started as a blog post landed my photograph on the cover of *Time* magazine, with a full spread to match. My role until this moment had been an artist and a concerned citizen. But by sharing the real-time, unfiltered evidence of my community's passion for Freddie Gray, I'd done the work of an activist. I've since committed to using my photography and art to tackle issues in my community and elevate the voices of the unheard.

Five years later, in the summer of 2020, I found myself at city hall again, protesting the killings of Breonna Taylor and George Floyd. In the eyes of protestors, I saw how this cycle of death and outrage had affected our people. Years of protesting have left me with anxiety, depression, and PTSD, but the importance of the work keeps me going. For me, personal justice and inner peace mean being the change I want to see and using my gifts to spark conversations.

I believe that Black people in America must control our narrative. We must document the times we live in—through protest, photography, and words, like those of the talented writers throughout this book. Our efforts are a part of a long history that has afforded us rights and will be remembered for generations to come. From the civil rights movement to Black Lives Matter, from "We Shall Overcome" to "No justice, no peace," the fight for change will be passed forward to the next generation. Our protests will continue to unlock doors to justice. We are equipped with a blueprint and strengthen future generations through our photos, books, poems, and art, which allow us to share our vision for the world we have dedicated ourselves to creating.

NO JUSTICE, NO PEACE.
DEVIN ALLEN

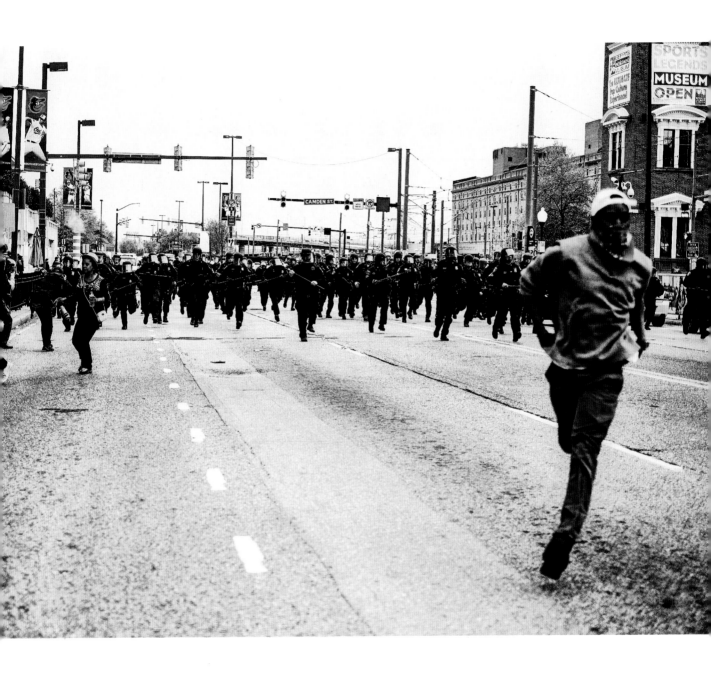

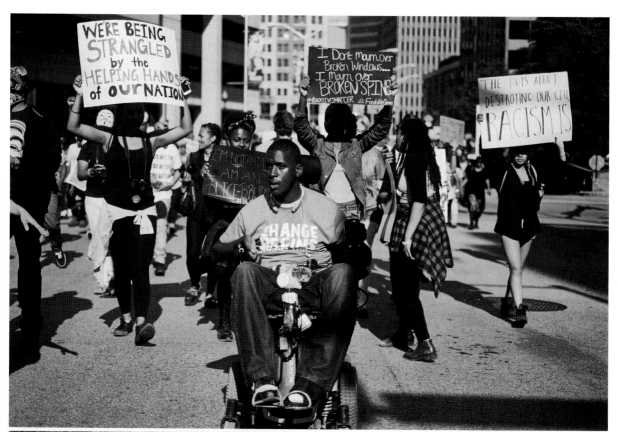

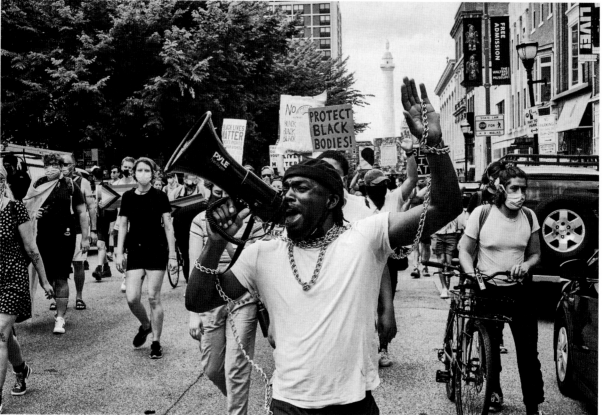

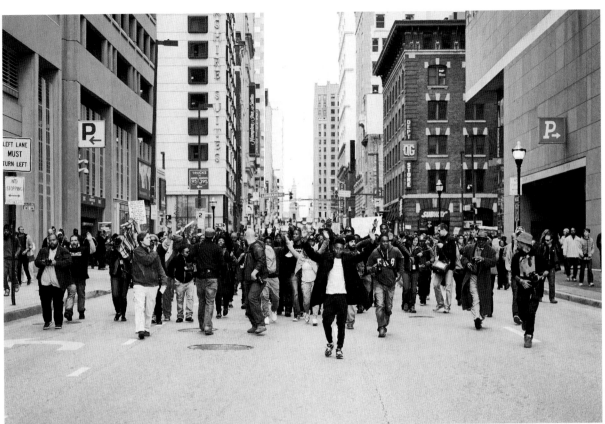

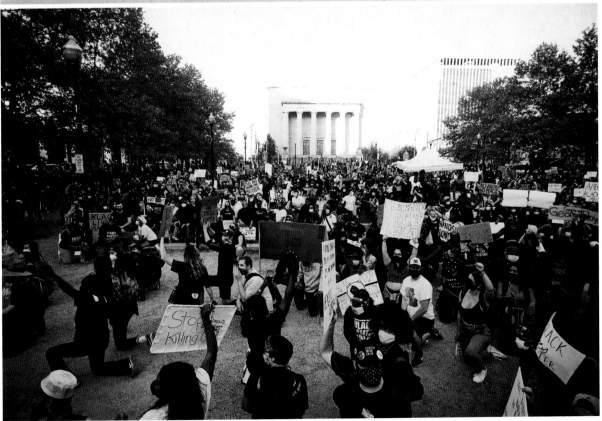

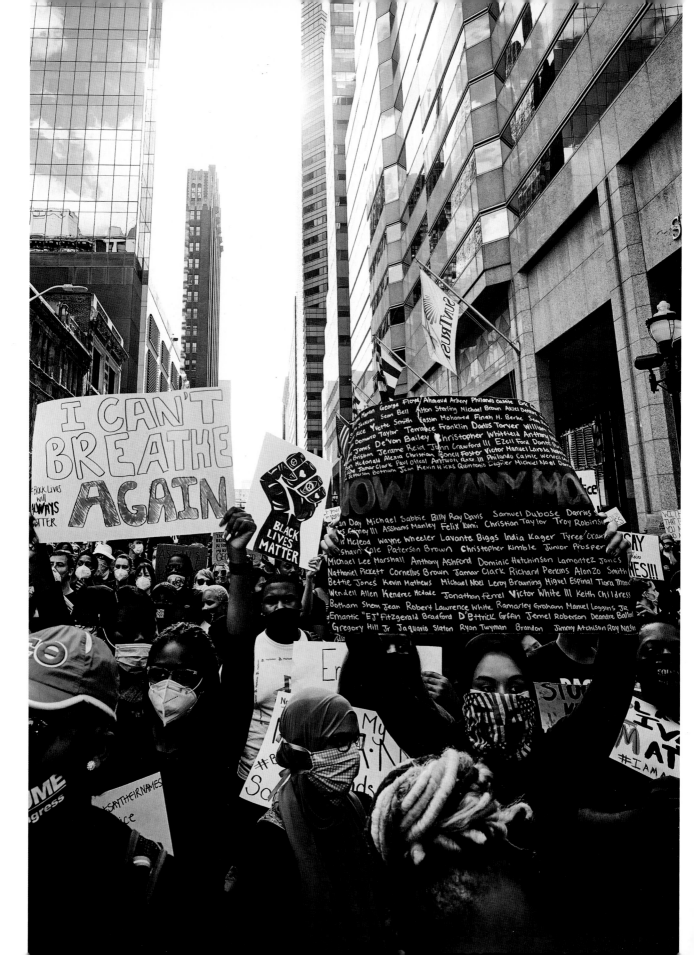

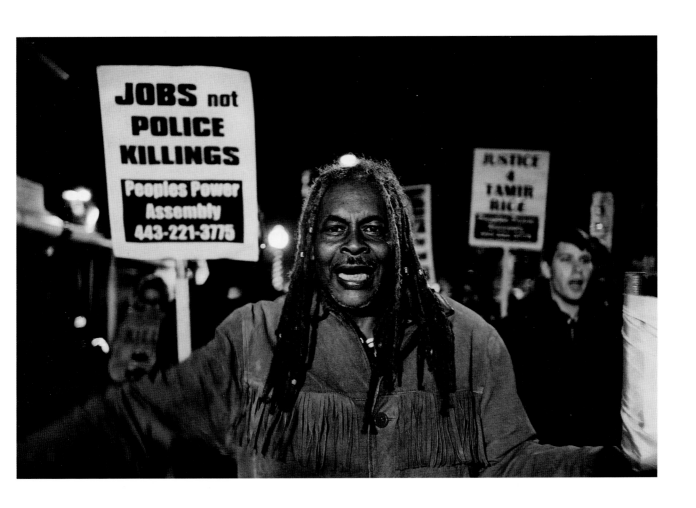

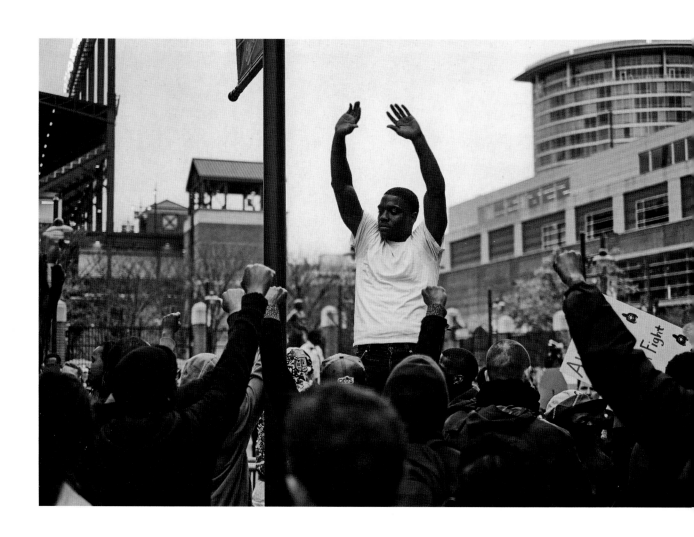

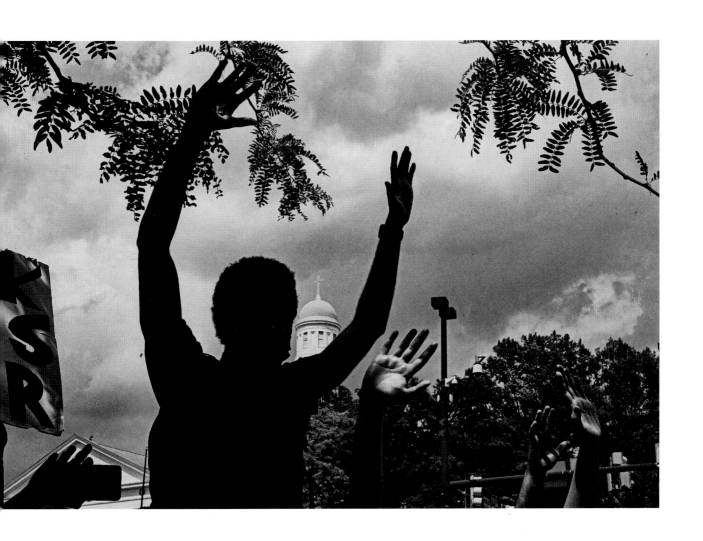

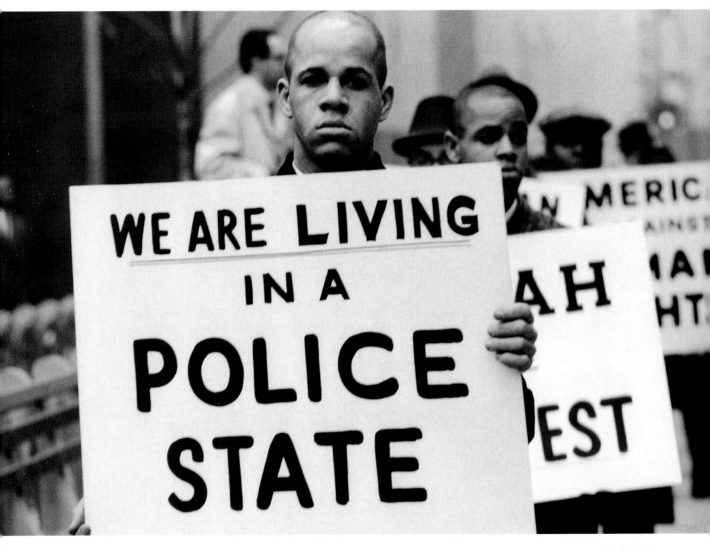

Gordon Parks

"THE FIRST
REVOLUTION
IS WHEN
YOU CHANGE
YOUR MIND."

—GIL SCOTT-HERON

HOW WE GET FREE

Keeanga-Yamahtta Taylor

One hundred years after Emancipation, African Americans dismantled the last vestiges of legal discrimination with the Civil Rights Movement, but the excitement of the movement quickly faded as American cities combusted with black people who were angry and disillusioned at being locked out of the riches of American society. Hundreds of thousands of African Americans participated in the uprisings in search of resolutions to the problems of lead poisoning, rat infestations, hunger and malnutrition, underemployment, poor schools, and persisting poverty.

Where liberals and radicals often converged was in the demand that blacks should have greater political control over their communities. For liberals, black electoral politics was a sign of political maturity as the movement left the streets for the poll booth, urban governance, and community control. The problem was not "the system"; it was exclusion from access to all that American society had to offer.

Some radicals were also lured by the possibility of self-governance and community control. Indeed, it was a viable strategy, given that much of black life was controlled by white elected officials and white-led institutions. The question remained, however: could the machinery wielded in the oppression of blacks now be retooled in the name of black self-determination?

If freedom had in one era been imagined as inclusion in the mainstream of American society, including access to its political and financial institutions, then the last fifty years have yielded a mixed record. Indeed, since the last gasps of the black insurgency in the 1970s, there are many measures of black accomplishment and achievement in a country where black people were never intended to survive as free people.

Is there no greater symbol of a certain kind of black accomplishment than a black president? For those who consider mastery of American politics and black political representation as the highest expression of inclusion in the mainstream, we are surely in the heyday of American

"race relations." Yet, paradoxically, at a moment when African Americans have achieved what no rational person could have imagined when the Civil War ended, we have simultaneously entered a new period of black protest, black radicalization, and the birth of a new black left.

No one knows what will come of this new political development, but many know the causes of its gestation. For as much success as some African Americans have achieved, 4 million black children live in poverty, 1 million black people are incarcerated, and 240,000 black people lost their homes as a result of the foreclosure crisis—resulting in the loss of hundreds of millions of dollars in black savings.

Never before in American history has a black president presided over the misery of millions of black people, the denial of the most basic standards for health, happiness, and basic humanity. Entertainer and activist Harry Belafonte recalled his last conversation with Martin Luther King Jr., in which King lamented, "I've come upon something that disturbs me deeply . . . We have fought hard and long for integration, as I believe we should have, and I know that we will win. But I've come to believe we're integrating into a burning house."

The aspiration of black liberation cannot be separated from what happens in the United States as a whole. Black life cannot be transformed while the country burns all around it. The fires consuming the United States are stoked by the widespread alienation of low-wage and meaningless work, unaffordable rents, suffocating debt, and the boredom of poverty.

The essence of economic inequality is borne out in a simple fact: there are 400 billionaires in the United States and 45 million people living in poverty. These are not parallel facts; they are intersecting facts. There are 400 American billionaires because there are 45 million people living in poverty. Profit comes at the expense of the living wage.

Corporate executives, university presidents, and capitalists in general are living the good life—because so many others are living a life of hardship. The struggle for black liberation, then, is not an abstract idea molded in isolation from the wider phenomenon of economic exploitation and inequality that pervades all of American society; it is intimately bound up with them.

The struggle for black liberation requires going beyond the standard narrative that black people have come a long way but have a long way to go—which, of course, says nothing about where it is that we are actually trying to get to. It requires understanding the origins and nature of black oppression and racism more generally. Most importantly, it requires a strategy, some sense of how we get from the current situation to the future.

Perhaps at its most basic level, black liberation implies a world where black people can live in peace, without the constant threat of the social, economic, and political woes of a society that places almost no value on the vast majority of black lives. It would mean living in a world where black lives matter.

While it is true that when black people get free, everyone gets free, black people in America cannot "get free" alone. In that sense, black liberation is bound up with the project of human liberation and social transformation.

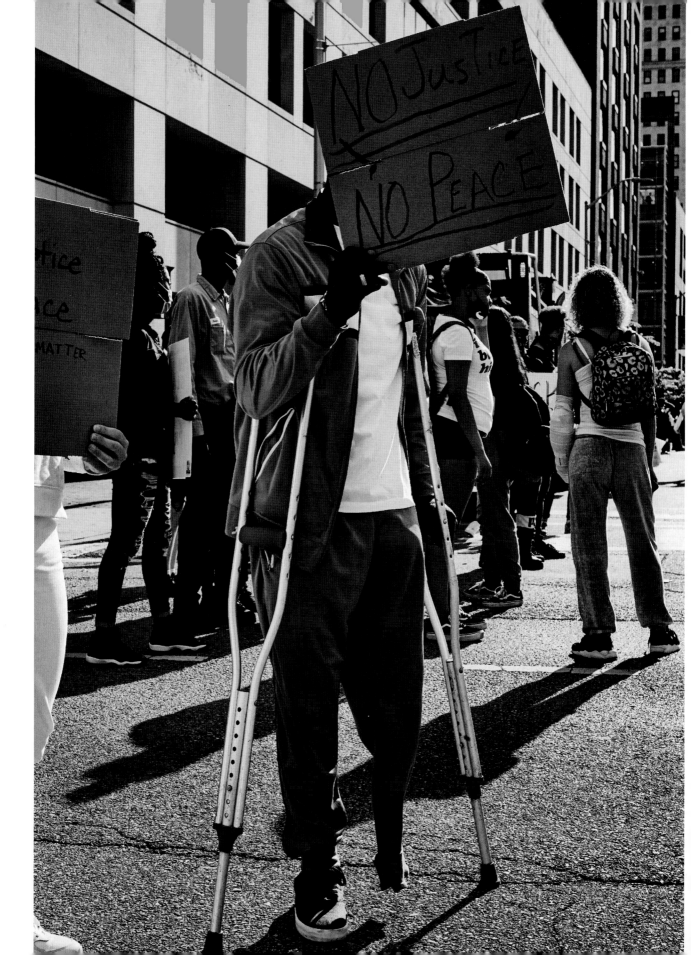

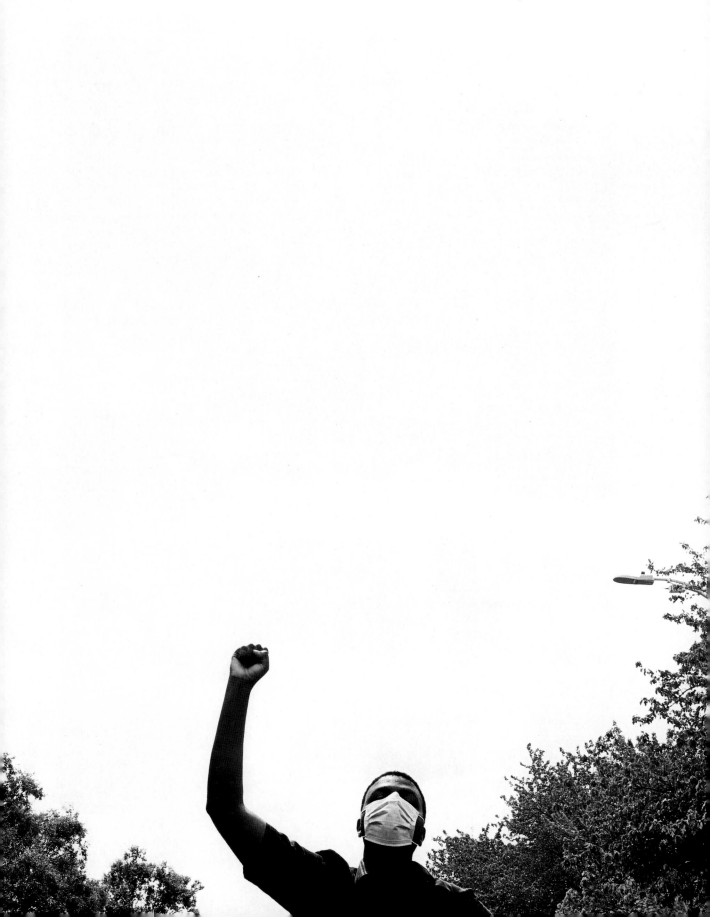

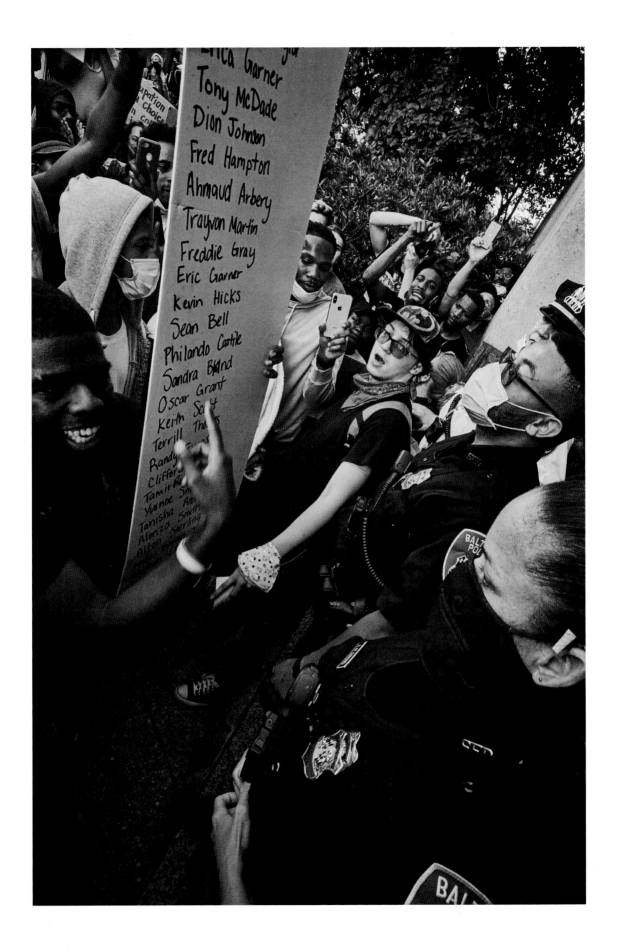

Black People Magic

Leslé Honoré

Freddie Gray

Was so magical

That he severed his own spine

Crushed his own voice box

Killed himself. Alone. Handcuffed

Sandra was so magical

That she hung herself

With invisible trash bags

From an unseen rafter

Taller than her

6 foot frame

Tamir was a wizard

That turned his toy gun

Into an AK in less than two seconds

Mike Brown was a sorcerer

Who could transform into a monster

Who could stand still

Hands in the air

And threaten a man with a gun

Eric Garner was so filled with ancestral power

He didn't need air to breathe

Don't you see

Unless we called the Ministry of Magic

There will never be a conviction in these courts

Another magician once told us

"THE MASTER'S TOOLS WILL NEVER DISMANTLE THE MASTER'S HOUSE."

—AUDRE LORDE

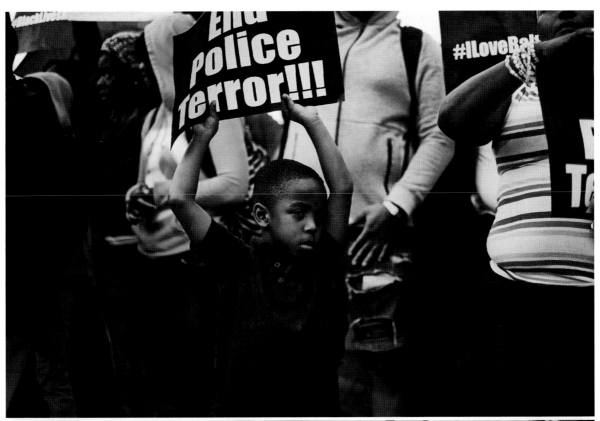

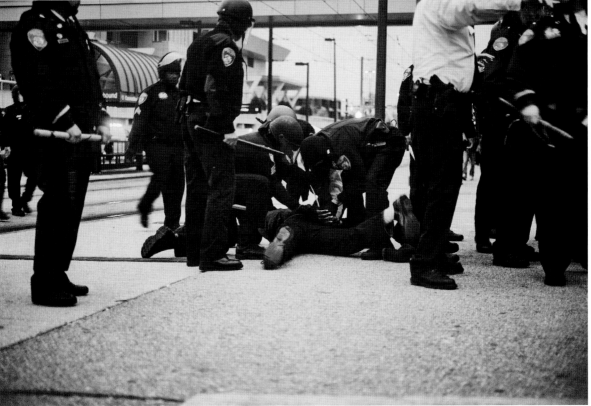

THE DAY AFTER THE PROTEST

D. Watkins

When the cameras leave and the idea of black people "mattering" falls back to the bottom of everyone's priority list, the real work starts.

Smoky, hollowed-out buildings, busted windows, shoes missing their pair, hair pieces and articles of clothing lying in the gutters, streets covered in empty water bottles, candy wrappers, bent and broken picket signs—that's the morning after a protest. It's the same morning scene I imagine many of the cities across America and across the world have been experiencing. Store owners boarding up busted windows, community members sweeping up trash while chatting about the night before, people nursing wounds and tender skin hit with rubber bullets or being released from holding cells.

On Memorial Day in Minneapolis, a white police officer and 19-year veteran of the force named Derek Chauvin took a knee on the back of the neck of George Floyd, an unarmed black man, for more than eight minutes. The whole incident was captured on video, clear enough for us to see and hear Floyd say "I can't breathe!" while groaning in pain. We can also see Chauvin's partner Tou Thao watching Floyd lose his life as if nothing is wrong. A total of four cops were involved in George Floyd's death— J. Alexander Kueng and Thomas Lane are the names of the other two officers. And finally, after global protest, divided countries and millions in damages, all have now been charged— Chauvin with second degree murder, and the other three with aiding and abetting. What was Floyd's crime? He allegedly tried to buy cigarettes from Cup Foods with a fake $20 bill.

Floyd's killing took place on the heels of

video surfacing of the shooting of Ahmaud Arbery, a 25-year-old black man who was hunted and gunned down by bloodthirsty white men in Georgia. Documentation of those deaths was followed by the release of the frantic audio of a 911 call from Kenneth Walker right after Louisville, Kentucky, police shot and killed his girlfriend, Breonna Taylor, a 26-year-old emergency medical technician; police were invading her home on a no-knock warrant looking for evidence in a drug investigation in which she was not a main suspect, in which no illegal substances were found. Then the Amy Cooper video went viral, showing her, a white woman, weaponizing the police against Christian Cooper, a birdwatching black man who simply asked her to follow the law and put her dog on a leash. Near Great-Depression-level unemployment while the nation had been pinned up in the house because of the deadly novel coronavirus, combined with all of these events and layered on top of reality TV character Donald Trump's election on a white supremacy platform in 2016, led to the explosion of protests and uprisings calling for justice for Floyd across the world.

The aftermath of Floyd's death was heard and seen on every news channel and radio station, all over social media, and probably somewhere in your own city as the story developed around the clock. Floyd's name was chanted in New York, Los Angeles, Cleveland, London, Paris, Louisville, Auckland, Berlin. Millions of people woke up to that day-after protest—or uprising, or riot—feeling for the first time. Connecting with other frustrated people, whether peaceful or destructive, felt good. The adrenaline, the energy, the unity, the feeling you get when you inject fear into the oppressive system that crushes you every day, the same way it crushed your mom and crushed your grandma and great-grandma too—I enjoyed that feeling for the first time in 2015. And let me tell you, it's like a drug.

In 2015 Freddie Gray, an unarmed 25-year-old black man, was stopped by a few rogue Baltimore city police officers. They had no legal reason for apprehending him, but they did anyway, arresting him for having a legal knife in his possession. He eventually died as a result of their incompetence, which sparked unrest and protest across the city.

On the first night I attended a "Justice for Freddie Gray" peace rally at Baltimore City Hall. Some community leaders and family members spoke and then we marched downtown. While passing Camden Yards, the stadium where the Orioles play, we were confronted by a mob of drunken Boston Red Sox fans. Red Sox games at Camden Yards are packed, so when we shouted "Justice for Freddie Gray," their drunken chants of "We don't care!" in response almost drowned us out. Then the beer-drenched Red Sox fans mixed in with our crowd, and some people got punched and slapped and tossed around (mostly them). I wasn't at the event as a protester, even though I'm a Baltimore native, resident and victim of police brutality. I was there as a reporter. But the rush from the fighting, yelling, chaos and expressed anger made me feel like we accomplished something. Things cooled off that night, but the collection of peaceful

protests, a few fires, some light looting, and dozens of harmless marches and gatherings that followed in the days after have become known collectively as the Baltimore Uprising.

Reactions to Floyd's death drastically outweighed Baltimore's response to Freddie Gray's killing. But activists in other cities that experienced unrest can learn from what we experienced in 2015, and what came after.

For starters, the cops involved with Freddie Gray's death—Caesar R. Goodson Jr., Garrett E. Miller, Edward M. Nero, William G. Porter, Brian W. Rice and Alicia D. White—are all still employed by the Baltimore City Police Department. They were charged, which felt like a win at the time; in fact, that played a role in quelling the unrest. But none were convicted. Not only did they refuse to accept any responsibility for Gray's death, they had the nerve to sue the city for false arrest, defamation and civil rights violations, even though a perfectly healthy man died on their watch.

The Minneapolis officer has been convicted in Floyd's death. The justice system—which law enforcement is, of course, a part of—can be slow and, as we saw in Baltimore, ultimately ineffective. In Louisville, the police officers responsible for Breonna Taylor's death were only terminated after public outrage on a global scale and months of protest. Louisville's police chief, Steve Conrad, was pressured into announcing his retirement in the aftermath, which Mayor Greg Fischer then accelerated by a month by relieving him of his command after police enforcing the emergency curfew shot and killed David McAtee, a black business owner—miles from any protests, at his home and business, with their body cameras off. Conrad keeps his pension.

Torn-apart cities prompt wealthy people to ask questions like, "Why would they tear their city apart?" as if it's really ours to begin with. They follow with questions like, "How can we use our money to fix the problems?" A lot of those rich people have halfway-good intentions. They are willing to put their money up in an effort to solve inequality's many related problems. But they rarely do enough research, and too often readily give money to up-and-coming oppressors who pair a great pitch with some nonprofit experience but no authentic connection to any oppressed community. These exploitative users receive the funding, and everyone wonders why nothing changes. The nonprofit pimps are famous for using poor black stories to fatten their pockets and disappear when the money runs out.

Most of us from places of struggle have seen them before. They come in all shades and colors, visit our blocks in their tweed jackets or dress shirts or relaxed-fit jeans, with their weird glasses and diet suggestions. They have their cell phones out, cameras ready to snap a pic with the poor kids out in front of a boarded-up house with some stupid "I love Bmore" hashtag. And then they use those images to strengthen their pitch, suck up the resources—maybe even get some celebrity love—and then it's off to the next tragedy: "Let me tell you about the groundbreaking work I did in Baltimore!" Resources given to their fictitious after-school programs, themed clubs, or junior

cop initiatives that could have helped people are instead squandered. And the neighborhoods still suffer.

And then there's the scariest scenario: What's the next move for protesters and the rest of the on-the-ground organizers when the marches end? I once heard a familiar voice yelling to an eager crowd: "We from Baltimore! So when they killed Freddie, we tore the city apart!" He ended with a line about revolution, burning your village down to keep yourself warm or something like that. I had to fold my lips tight to keep from laughing. This was in Boston, where I traveled for a speaking gig on the modern Civil Rights movement. I heard a guy from Baltimore, who I won't name, telling the crowd that he destroyed property, fought cops, and kicked ass during the unrest. I know he watched it all from the couch, because he told me that he stayed in the house glued to CNN until everything calmed down. "I ain't going out there with those crazy people!" he told me at the time. But just like the nonprofit pimps, he found a lane for himself where he can trade pain for profit. Meanwhile, the actual kids on the frontlines who orchestrated the uprising still suffer.

While revolutionary speech-giving guy was on his rant in Boston, Gregory Lee Butler Jr., a kid who allegedly poked a hole in a fire hose during the unrest in Baltimore, was sentenced to three years of supervised release and 250 hours of community service and ordered to pay $1 million in restitution. The government was fighting for a 33-month sentence. The most troubling part of the whole ordeal is that Butler spent five weeks in

federal detention before his sentencing; he spent more time in jail over a damaged fire hose than the officers charged with killing Freddie Gray did. Raymon Carter, 24 at the time, was sentenced to four years in prison after taking a plea deal when charged with setting a CVS on fire, and was ordered to pay $500,000 in restitution, after he was caught on tape and handed over to the authorities for a $10,000 reward.

Donta Betts, a 20-year-old with documented "cognitive limitations," was sentenced to 15 years in federal prison for setting fires during the unrest and for shooting a person in the leg over a drug dispute. Betts even told the judge, "I'm very sorry for my bad decision making," a larger display of empathy than any seen from the cops over Freddie Gray's death. And still he will spend a significant amount of his life in prison, while the officers went back to work, and will retire with their pensions.

These young men were part of the heart and soul of the Baltimore Uprising—they are part of the reason why national resources were poured into the city, why nonprofits were funded, why Baltimore was placed under a consent decree, why outsiders started acknowledging the racism that exists within the police department, and why so many people are expressing their frustrations over the death of Floyd in a similar manner. And they were all jailed, heavily fined, sold out by people they may have mistakenly advocated for, and then forgotten about. That is another tragedy.

Peaceful protest flyers for George Floyd rallies in Baltimore started popping up online. People I

hadn't seen doing any type of community any-thing since Freddie Gray died in 2015 began to resurface with their same agendas, tagging me in posts and looking for support.

"You think they gonna go crazy downtown again?" a friend asked me.

"No, because many of the kids who were on the ground, challenging the cops, and forcing the city to acknowledge our pain are sitting in prison. Their friends and cousins are less likely to make the same sacrifices. And I don't blame them."

I didn't go to any of the protests that time. The hard work starts when the demonstrations end, the cameras leave, and the public stops paying attention. That's when you can connect with the mentors who make sure kids get to school with clean clothes; the community organizers who host the neighborhood clean-ups; the artists who share their gifts of creativity; the coaches who channel kids' energy into team sports; the dance teachers who offer free classes; and the rest of the people who invest in the social fabric of oppressed com-munities and help us fight to change the narrative for real.

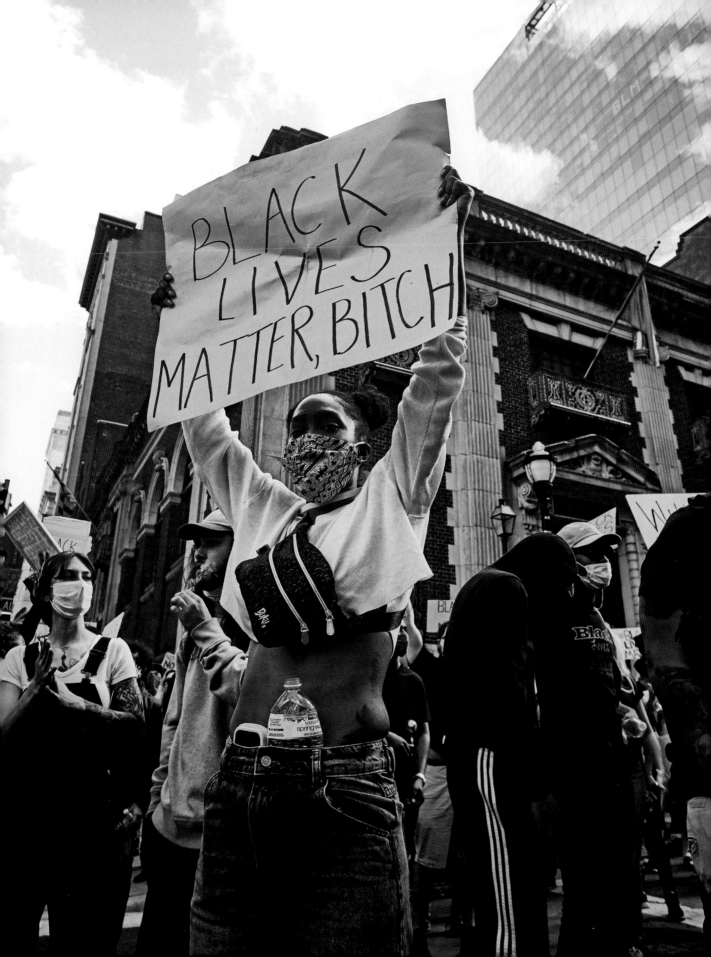

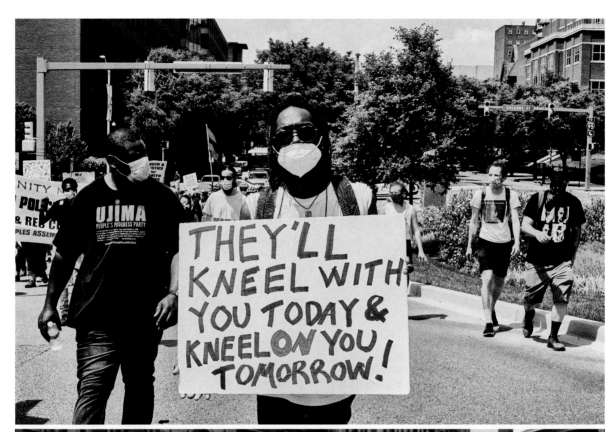

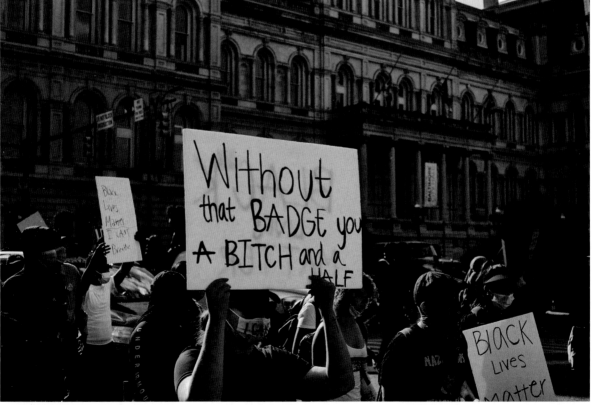

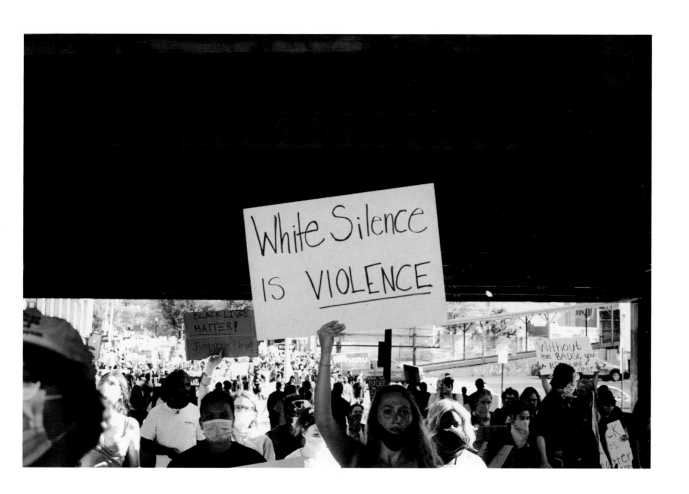

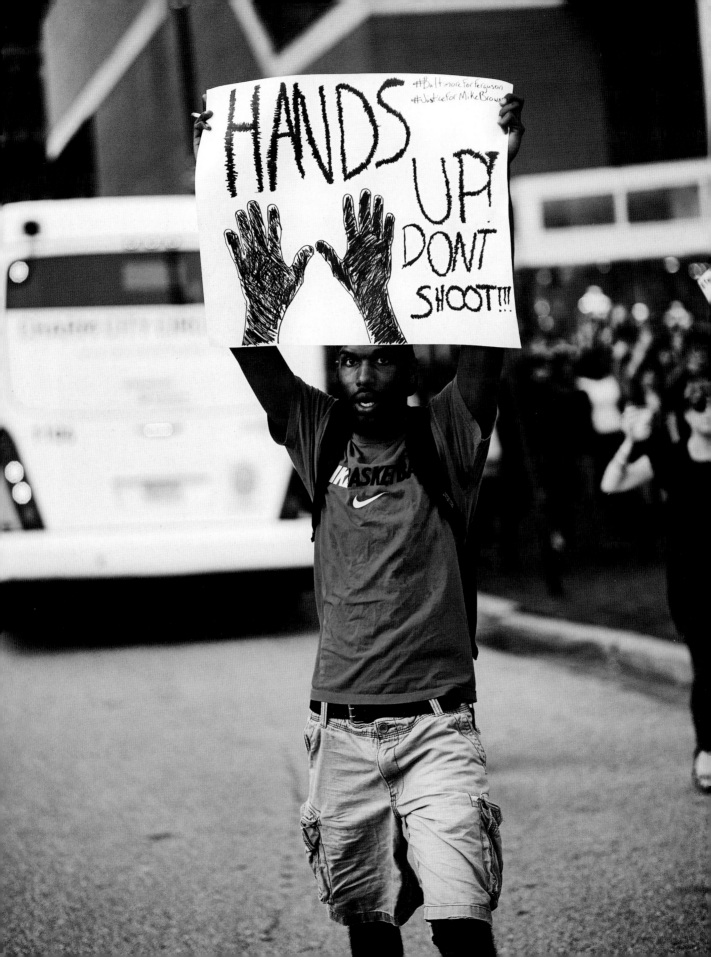

"I Can't Breathe . . ."

Dominique Christina

Eric Garner said he couldn't breathe.

And Elijah McClain said *he* couldn't.

George Floyd said he couldn't breathe either.

We know that because . . . we saw it.

We didn't need anybody to tell us.

We *saw* it.

And when you watch a man ghost his own body

While pleading for the rights to it,

You are not the same after.

Fact is, you can't *unsee* it and for some of us,

That fact gets stitched to your insides in a way that feels like war.

I got a bone to pick.

Modern-day slave catchers are as they've always been . . . scared . . . and entitled.

That combination is a Molotov cocktail

If you're the one they're afraid of.

I went to Baltimore when they murdered Freddie Gray.

Had to.

Freddie was ours and you could feel that no matter where you were.

Freddie is ours the way Elijah is and

Eric is and Trayvon is and

Mike Brown is and Sandra Bland is because

They all belong to us and we belong to them

Which is to say when they are pushed off the planet and

There's a cop (read: slave catcher) standing over the body

We feel that old ancestral logic bubble forward that says:

Fight Run Live.

I saw a fourteen-year-old stand a cop down.

He had a pipe.

The cop had riot gear

Replete with baton, Taser, pistol, and the backing of the state.

You know . . . whole shit.

The fourteen-year-old just wasn't interested in being afraid.

He was done.

He told me he was done.

He told anybody within earshot he was done.

And we believed him.

We know what it looks like when lions grow tired of being moved by lambs.

Eventually a lion remembers he is a lion.

Point is, Black people been dying.

Been impossible.

Been supernatural.

Been insistent.

Been resistant.

Been insistent.

We been knocked down nine times,

Resurrected ten.

Been defiant.

Been broken.

Been transcendent.

Been and been and been, yep.

Baltimore as Middle Passage take one:

Black man arrested violently.

People look on.

Cut to cop shoving black man in van.

Black man is howling.

Cut to neighborhood watching.

Breaking news:

An African American man was arrested in Baltimore today and suffers a severe spinal cord
 injury as a result of what some are calling a "rough ride."

Cut to CNN

Don Lemon will say some shit about

Questionable police practices in

African American communities
Cut to Freddie Gray's pleading face
Freeze frame
The mayor is speaking now
Protestors are gathering in Sandtown-Winchester
Cut to commercial
Gotta pay the bills

There's a sister with her right hand extended
Mouth wide open
Eyes fixed on something off camera to the left
V-neck collared shirt with stripes
Beautiful in her outrage
You know . . . like we be

She looks like a hex
She looks like a home

What I'm trying to say is
We gon' always fight and
Be in our magic
We gon' bury our dead and
Sing what songs we know

We gon' be what you're afraid of.
We gon' be what you're afraid of.

And you know it.
Every day you know it.
Cut to fourteen-year-old carrying pipe.
Cut to cop in riot gear backing down.
Cut to sister in striped shirt shrieking
Cut
Cut
Cut

Gotta pay
Gotta pay

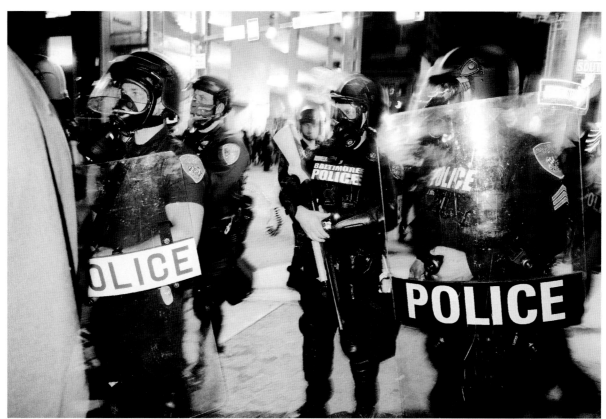

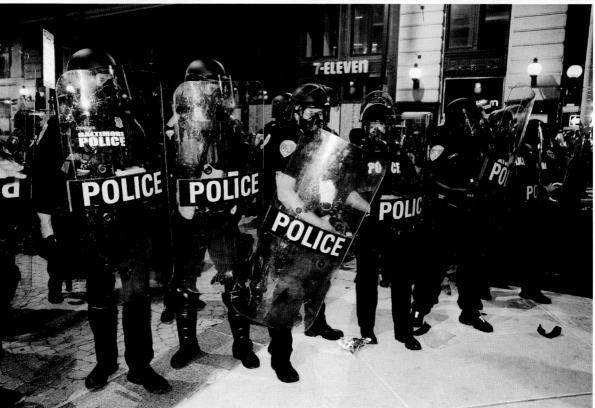

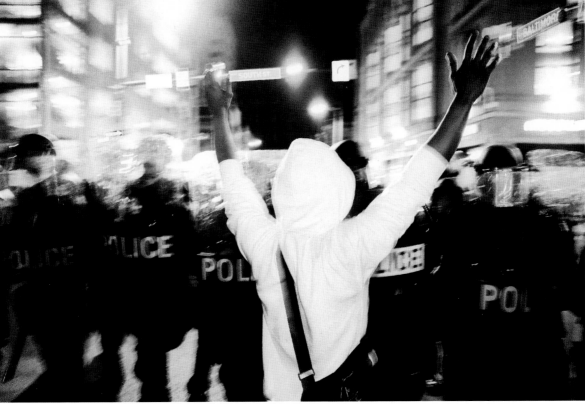

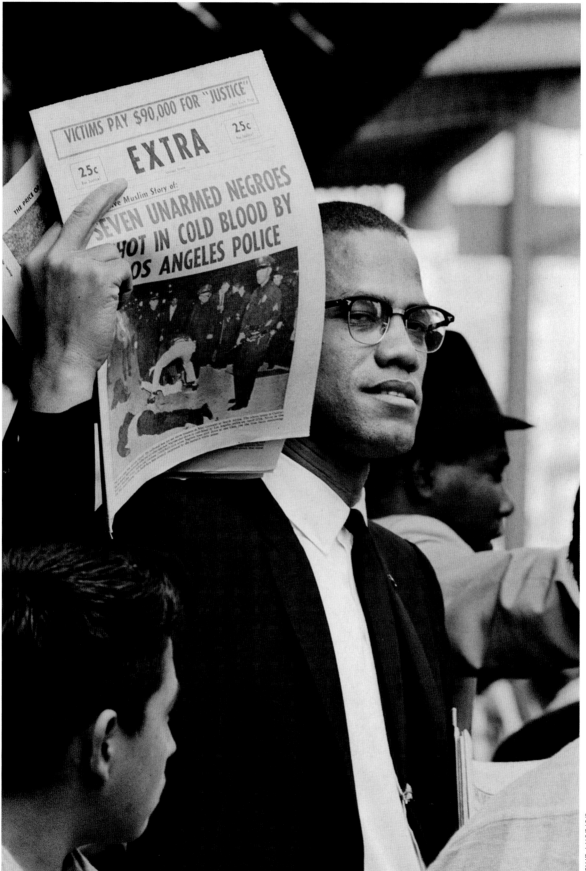

The newspaper headline reads:

VICTIMS PAY $90,000 FOR "JUSTICE"

EXTRA

25¢ 25¢

...ve Muslim Story of:

SEVEN UNARMED NEGROES
SHOT IN COLD BLOOD BY
LOS ANGELES POLICE

"WE WANT FREEDOM BY ANY MEANS NECESSARY. WE WANT JUSTICE BY ANY MEANS NECESSARY. WE WANT EQUALITY BY ANY MEANS NECESSARY."

—MALCOLM X

WHY I BECAME AN ABOLITIONIST

Brea Baker

On February 26, 2012, Trayvon Martin was assassinated. I use the word *assassinated* because his killing was absolutely political—especially for Black America. Like Trayvon, I was 17 years old at the time. Up until that point, I believed in a post-racial America. I had come of age without the influence of social media and lived in a predominantly Black and Brown community where everyone was on similar socioeconomic footing, which insulated me from structural injustices. I was so insulated that even after Trayvon's death, I believed vehemently that *justice* would be served. Summer 2013 would be the moment I knew this country wasn't capable of justice—and that a radical shift was needed.

That summer, after more than a year of advocacy, the non-acquittal came in. I felt so debilitated by the crushing weight of disappointment and betrayal (something I would unfortunately become familiar with). I was a first-year student in college being told that the world was my oyster, but that didn't ring true for my community. It was bigger than Trayvon at that point. His death had pulled back my blinders and allowed me to see the widespread racial *and* economic inequities of this country. Suddenly, I was seeing the community I grew up in differently from the multiracial utopia I remembered from childhood. Suddenly, I was realizing that the diversity I loved was a product of segregation and that my college peers had far different experiences than I did. I had to come to terms with the fact that although Trayvon's death was a "wake-up call" for me, there were so many other victims of vigilante, police, and/or white supremacist violence. It left me feeling extremely helpless—and played.

I might have stayed in that mental space

had it not been for three defining moments that pointed me toward the solution that had been recommended not for years, or decades, but *centuries*: abolition. Abolition is just as it sounds: a commitment to eradicating and replacing harmful systems rather than incrementally reforming them. Though mostly associated with the 19th-century movement to end chattel slavery, abolition is an evergreen framework for effecting change that prioritizes radical imagination. Instead of inheriting the society that was passed on to us, we have the opportunity to build a society that works for our evolving communities and needs. Thus, abolition is an ongoing process of assessing and replacing any system that doesn't serve *all* of us. It goes beyond the tearing down to also include the rebuilding that must take place.

I underwent a deep independent learning journey curating a personal syllabus that included Assata Shakur, Angela Davis, Michelle Alexander, and many others who called themselves abolitionists. This was my first introduction to the term in a modern sense. It didn't take long for me to realize that this country was founded on racist pretenses that put profit over people consistently. The books I was reading advocated that we start over if we want to build a society that serves all of us. That resonated with me and helped explain why our centuries of reforms had only cemented systems of oppression. It was because we had never invested in root causes, only quick fixes for symptoms.

Then, the summer between my junior and senior year of college, I interned at the Public Defender Service DC, working with attorneys representing people charged with felonies and unable to afford representation. My mind was opened to how our society fails people in ways that change their behavior. I stopped seeing the world in swaths of good and bad, and recognized that our punitive society first stems from a refusal to help people evolve past who they once were and what they once did. It also became clear there could be no justice in such an intentionally broken system. I learned to trade the word *crime* for *harm*, because a lot of criminalized behaviors don't actually hurt others, and a lot of actions that *do* hurt people are never addressed under our current system.

It struck down the norms I had accepted as "the way things always were," and for the first time, I began to imagine what could be. The books I read had taken me as far as I could go theory-wise, but to truly consider myself an abolitionist, I needed to interrogate all the ways my actions upheld the belief that people were disposable. It required making intentional choices and interrupting my own thoughts. It transformed my interpersonal relationships and how I spent money. For example, I couldn't call myself an abolitionist while still regularly ordering through Amazon, a company I see as invested in racist surveillance tactics and whose business model comes at the expense of poor people. This ongoing learning process, coupled with a brave space for exploring the practice of abolition, has been so instrumental to my journey. That work never ends as our society evolves and new questions continue to pop up.

A more recent phase of my development as an abolitionist has been recognizing that oppression is fostered in an ecosystem, and thus, abolition

cannot be siloed to one field. To put that more plainly: Abolishing one system while not examining the ways other industries are also plagued by institutional racism is counterproductive. If we abolished policing as we know it tomorrow without transforming capitalism, medical racism, social work, and the school-to-prison pipeline, we wouldn't actually eradicate systemic racism at all. This is especially the case when we realize that abolishing our current criminal legal system would depend on a network of community groups being capable of serving a community with diverse needs. Our country was built for wealthy, white men, and if our goal is to change that, we must do so holistically. This is where intersectionality takes center stage as we ensure our work on racial justice doesn't leave anyone behind. Our picture-perfect society is failing people in many ways, and any aspiring abolitionist should look at the full landscape of which institutions create those failures. Like a Venn diagram, we can identify which institutions have the capacity to overlap and fill existing voids versus those that need to be transformed altogether.

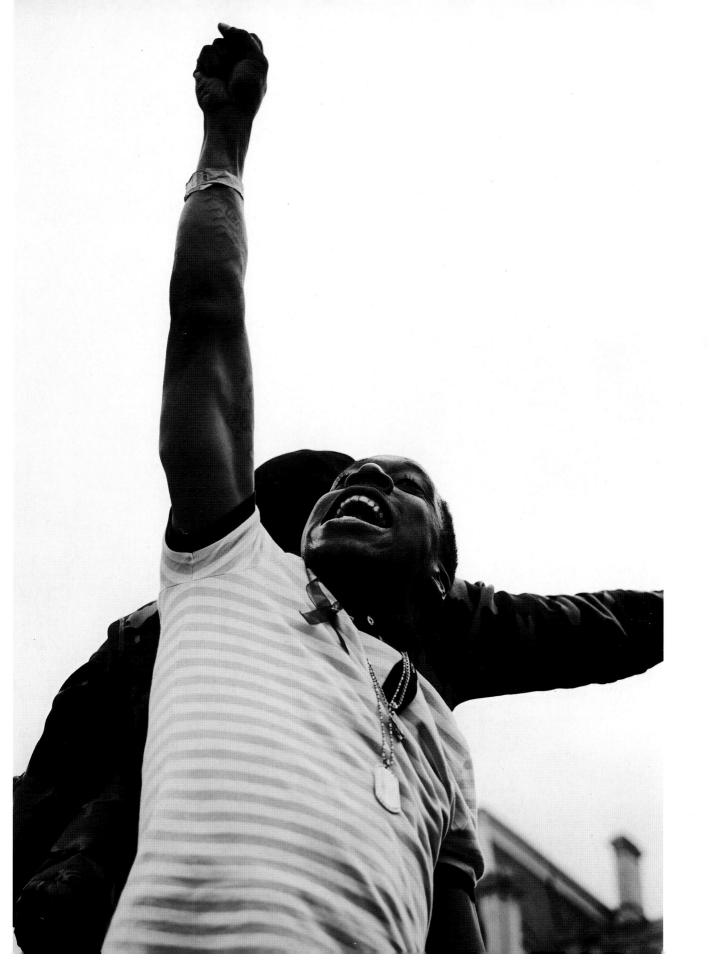

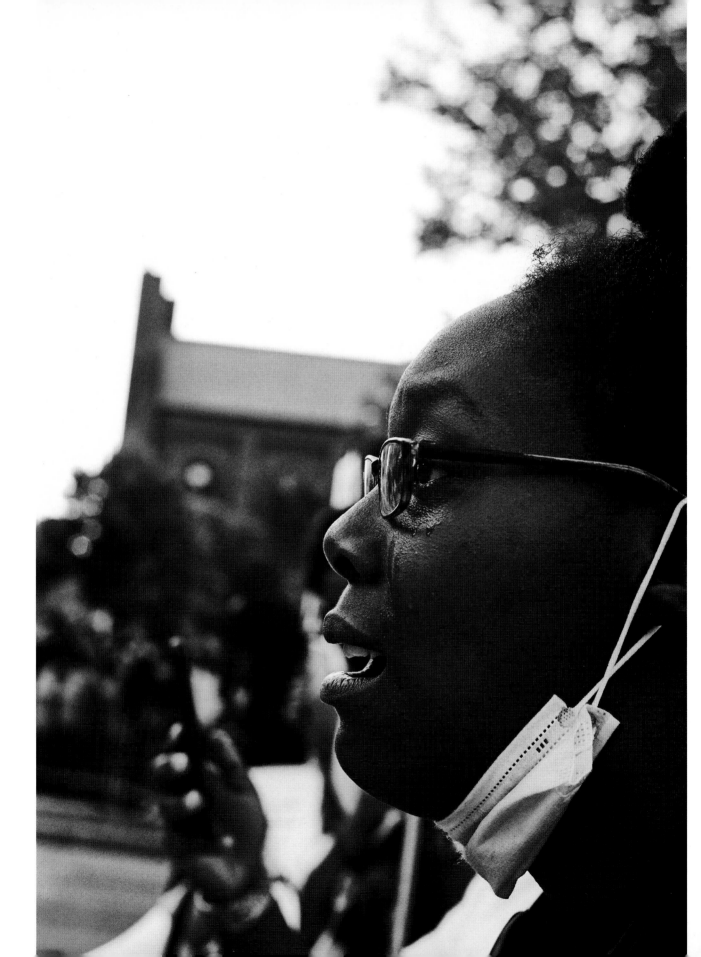

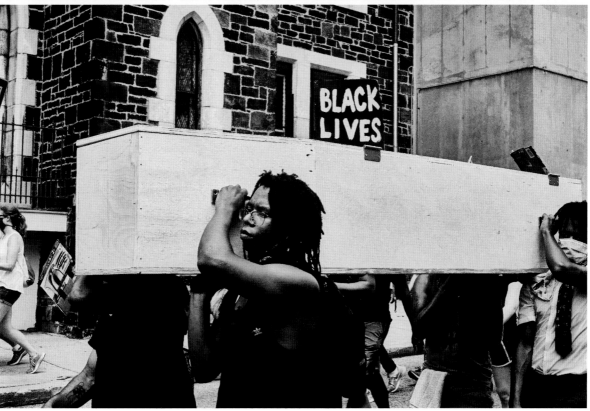

OUR BROTHER, SEAN, AND PUTTING FAMILIES FIRST

Ashley and Michelle Monterrosa

At twenty-two years old, our brother, Sean Monterrosa, was the middle child; we three siblings were each born two years apart. Michelle was the oldest, at twenty-four, and Ashley the youngest, at twenty, when Sean was taken from us in June of 2020. On a summer night outside of a Walgreens in Vallejo, California, our brother was shot through the windshield of an unmarked police car by a Vallejo Police Department officer. Sean was kneeling with his hands up.

The moment we got the news of Sean's death, we sprang into action. There was no time to grieve. We had to divide our days between planning the funeral, giving media interviews, organizing protests, and starting a social media campaign for justice, all while trying to understand what had happened to our brother.

In our fight for answers and accountability, we've learned that a large part of our police justice work is humanizing our brother. The last time we heard from Sean, who was a carpenter and union man, he was asking us to sign a petition for George Floyd. Sean was that kind of guy. He didn't consider himself an activist. He was being intentional and reflective, and he cared for people. No family should have to suffer in silence after a police killing or beg for crumbs of justice. Family members of other victims of police brutality have welcomed us into "the club no one wants to join." We have become committed to creating a system of public safety by and for our communities. In this club, we work to make sure no other parents, siblings, or extended families experience our shared pain. In this club, we show up because of our lived reality; our mourning has moved us to action.

We understand and accept the call to advocate not only for those like Sean who are no

longer here to advocate for themselves. There is no action blueprint for a family impacted by police violence. We have worked tirelessly to get answers from the Vallejo Police Department and the City of Vallejo. We had to grieve publicly and put our bodies on the line when what we truly needed was professional support and transparency. We have had to show up on an elected official's lawn and apply pressure for police accountability. And still, we were left in the dark with no answers for weeks.

California attorney general Rob Bonta stepped in, and his office continues to investigate Sean's killing. While Bonta's office and the Vallejo Police Department have promised transparency, we believe that time has passed. Transparency would have looked like the Vallejo Police Department releasing the video footage from that summer night immediately. It would have looked like clear communication with our family, rather than us having to go on a wild-goose chase for answers. By pushing for the removal of all officers involved in Sean's death, the appointment of an impartial special prosecutor to investigate Sean's case, and the exposure of the entire Vallejo Police Department's violent policing practices, we are actually advocating for the safety of our community's families.

Officer Jarrett Tonn had shot at three civilians prior to Sean during his career. Sean was his first fatality. Body-camera footage later emerged of Tonn, upon realizing that he had the life of a young brown man on his hands, saying, "This is not what I fucking needed tonight." Tonn was placed on administrative leave but was back at work just months later.

According to former Vallejo police captain John Whitney, Vallejo Police Department officers bend the points of their star-shaped badges to signify how many lives they have taken. They celebrate killings with barbecues—community gatherings of officers celebrating joyous memories of stolen dreams and robbed futures—and bend their badges to commemorate what they have done to thirty-seven unarmed black and brown men since 1997 (nineteen of them since 2010) and to our brother, Sean. Whistleblowers like Whitney have been fired for speaking out about the frat-like police culture. Since then, several high-ranking members of the Solano County Sheriff's Office have been exposed for public support of a far-right extremist group.

We hope every family affected by this sort of policing will join us in a pursuit of justice. Family members of those murdered by police deserve justice, peace, and joy. They deserve care and empathy and to have a voice in a matter that is affecting our families. Grieving families need to be heard by community leaders, those protesting, and the decision makers who have the power to implement lifesaving legislation. Activists and organizers have shown up for us and walked alongside us in shared commitment to restoration and healing not just for our family, but for every family in our community facing a similar loss, and we need that to continue.

When it gets too hard to fight this battle and we feel like we can't go on, as sisters we lean on each other and on our mom's reminder that "God does not give hard battles to weak soldiers."

The last text from Sean was a literal call to action: "Here's the baton. Now take it and run."

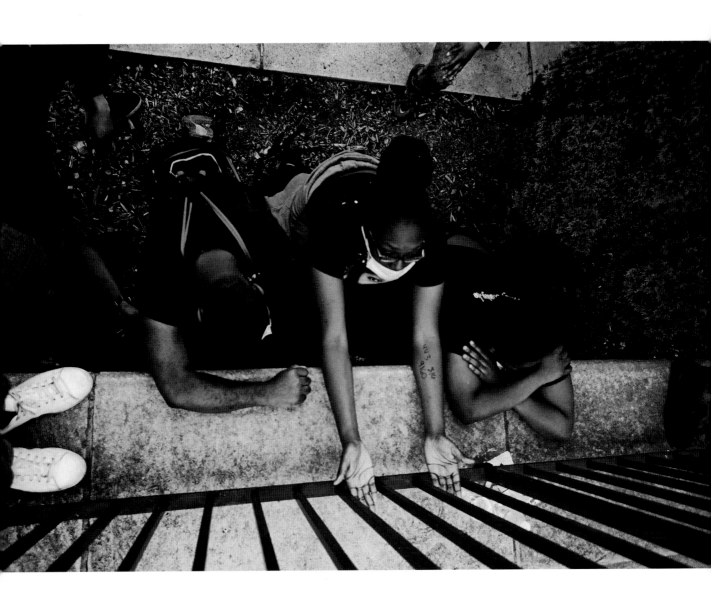

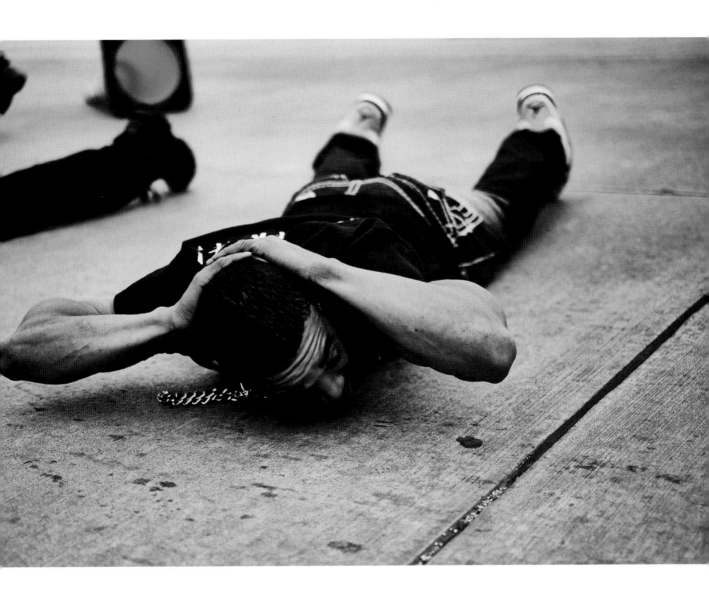

REMEMBERING BIG FLOYD

Lawrence Burney

A native of Houston's Third Ward, George Floyd was an affiliate of DJ Screw, one of the most innovative figures in hip-hop's history, and his legendary Screwed Up Click. Floyd's life, at just forty-six years old, was cut short when a white police officer in Minnesota planted a knee onto Floyd's neck and suffocated him to death. Shortly after his passing, fans of Screwed Up Click began sharing what many Texans had already been aware of: Floyd's features on Screw tapes from the '90s. He rapped under the name Big Floyd.

One track that surfaced is a twenty-four-minute song titled "So Tired of Ballin." Big Floyd enters around the fourteen-minute mark, when DJ Screw introduces him with an encouraging "Come on, Big Floyd!" Floyd proceeds to glide over a slow, funky beat. He's boasting about his Third Ward roots, dreaming of driving a drop-

top Bentley, and showing his "raw naked hide." He goes on for two minutes straight with heated lyrics. On another track, Big Floyd and an artist named Daryl rap over a Screwed version of AZ's "Sugar Hill." There, Floyd waxes poetic about the things he wants to obtain in life: a mansion for his mother, freedom from the stress of bills, and a daily rotation of four-course meals at fancy restaurants. Recently, a dedicated fan of Big Floyd's isolated and uploaded his verse on a song called "Sittin' on Top of the World" from DJ Screw's 1996 *Chapter 324: Dusk 2 Dawn* mixtape. Floyd took that opportunity to further affirm his love for the Third Ward and everything that came with it: having drinks and a smoke with his friends and the very Houston tradition of "chopping blades," which means riding in low cars with big rims.

When a Black person dies at the hands of

racist law enforcement, we are thrown into a thick surreal cycle of footage of the event, whether we seek it out or not. That individual's personhood is often compromised as their life enters the public sphere. No longer seen in the fullness of a human being, they become a politicized spectacle. It is rare that we get to see how they contributed to the greater human experience before their life was taken away. These tapes offer George Floyd a chance to speak for himself, even after his voice and his life were taken away. They offer the public a real, and not artificial, sense of what Floyd meant to his community while he was living. He contributed to a genre of hip-hop that has proudly represented his hometown, that has garnered international respect, and that offered him a chance to expand as a person.

In the aftermath of George Floyd's death, many that knew him have come forward to redirect attention to the type of person he was while still here. Former NBA player Stephen Jackson, who grew up with Floyd in Houston's Third Ward, took to Instagram to eulogize his friend (whom he called Twin because they resembled each other): "Twin couldn't wait to tell me he moved to Minnesota to work and drive trucks. He knew he had to relocate to be his best self. His ♥ was in the right place."

Courteney Ross, a friend of Floyd's, told Minnesota's WCCO, "He stood up for people, he was there for people when they were down, he loved people that were thrown away." Jovanni Thunstrom, the owner of the restaurant where Floyd worked security, told CNN, "He was loved by all my employees and my customers. He was my friend."

Every personal account of Floyd has consistently shown that he was a decent person and one that looked out for others. It is important to share these caring snapshots because they underline that Black people are entitled to a sense of individuality, something that many white Americans (cops or otherwise) repeatedly fail to understand.

Rest in peace to George Floyd, a.k.a. Big Floyd of the Screwed Up Click. Let us remember him as an artist, a beloved member of his community, and a man ready to start a new chapter, a chapter that has changed the world.

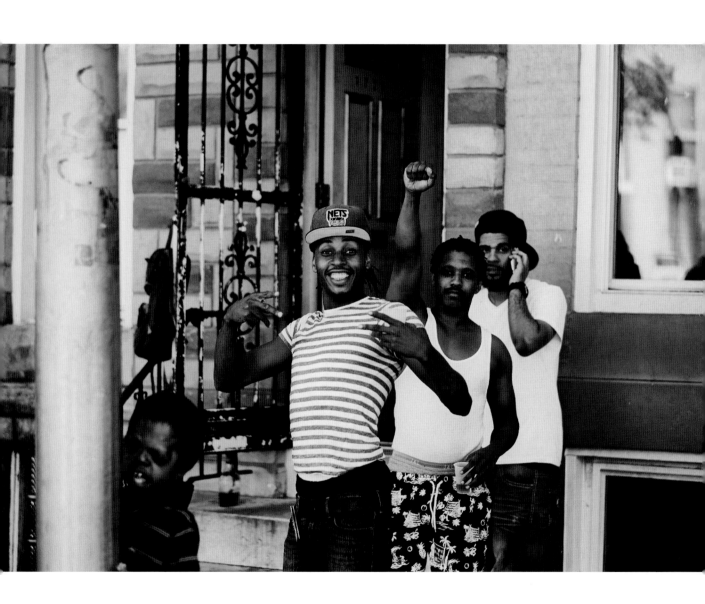

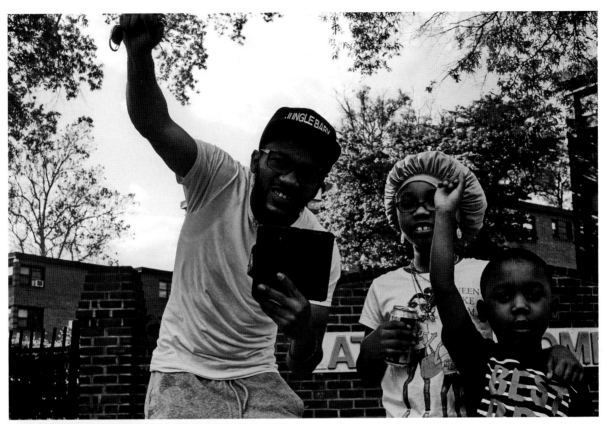

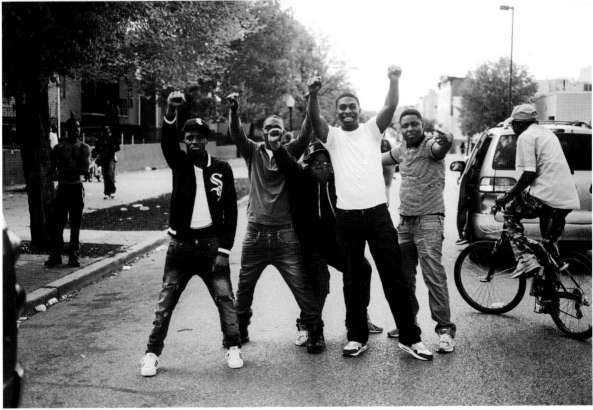

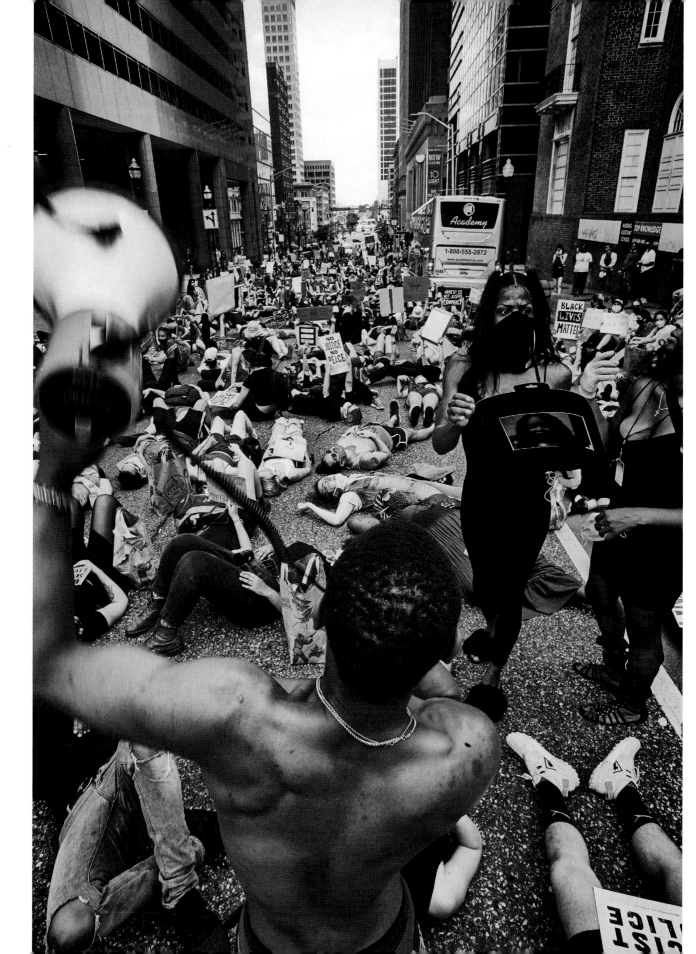

When people say, "We have made it through worse before"

Clint Smith

all I hear is the wind slapping against the gravestones
of those who did not make it, those who did not
survive to see the confetti fall from the sky, those who

did not live to watch the parade roll down the street.
I have grown accustomed to a lifetime of aphorisms
meant to assuage my fears, pithy sayings meant to

convey that everything ends up fine in the end. There is no
solace in rearranging language to make a different word
tell the same lie. Sometimes the moral arc of the universe

does not bend in a direction that will comfort us.
Sometimes it bends in ways we don't expect & there are
people who fall off in the process. Please, dear reader,

do not say I am hopeless, I believe there is a better future
to fight for, I simply accept the possibility that I may not
live to see it. I have grown weary of telling myself lies

that I might one day begin to believe. We are not all left
standing after the war has ended. Some of us have
become ghosts by the time the dust has settled.

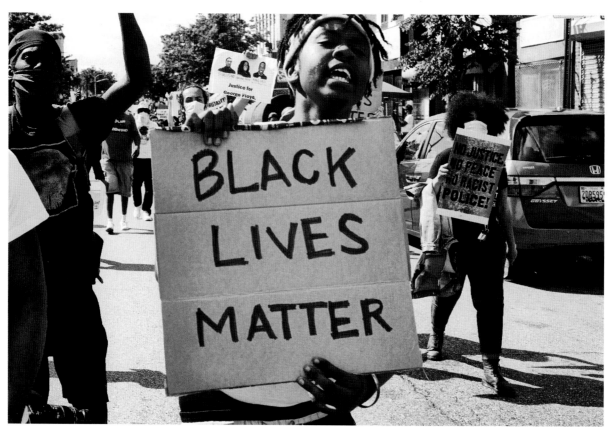

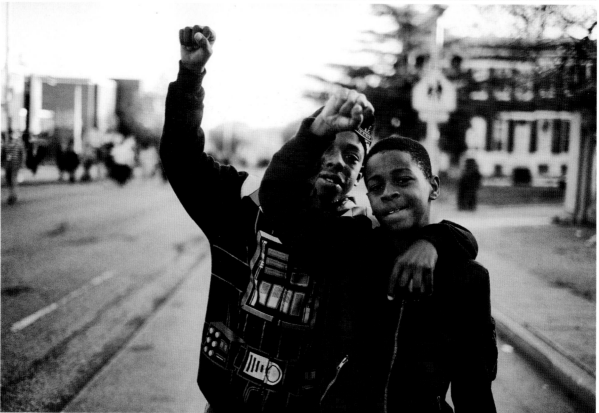

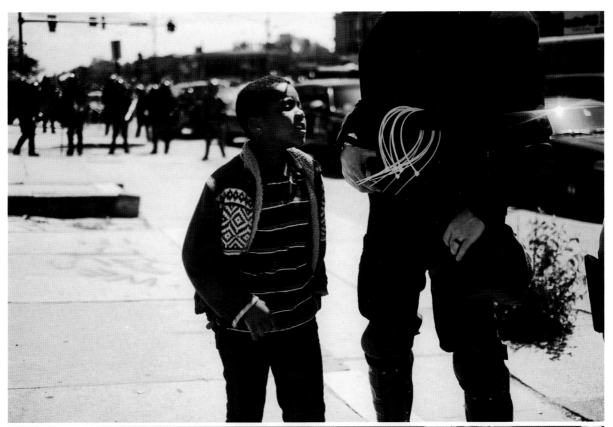

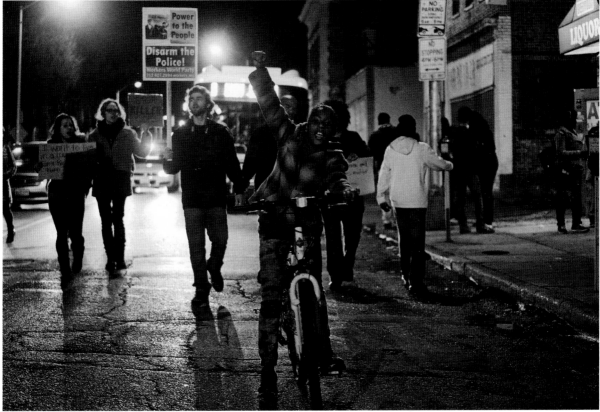

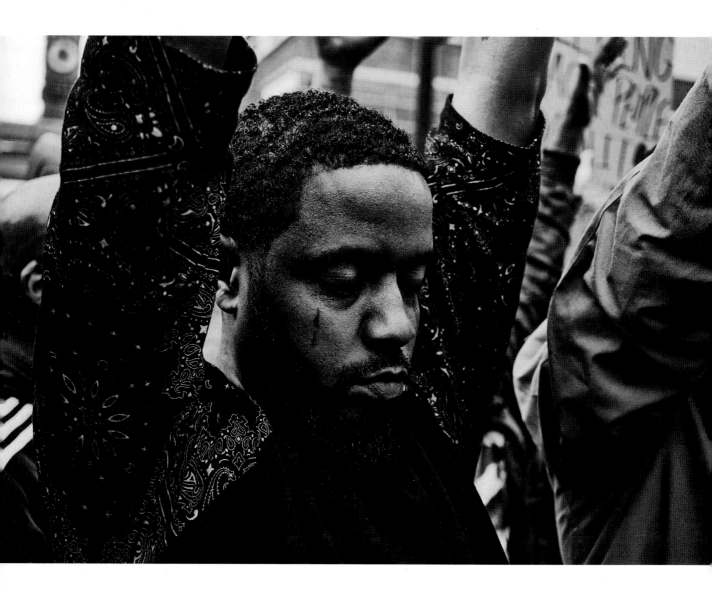

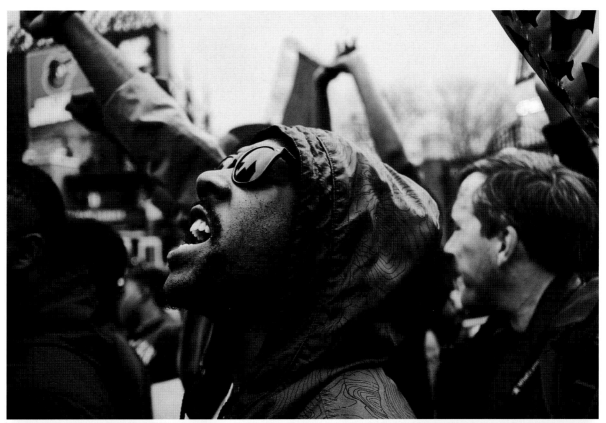

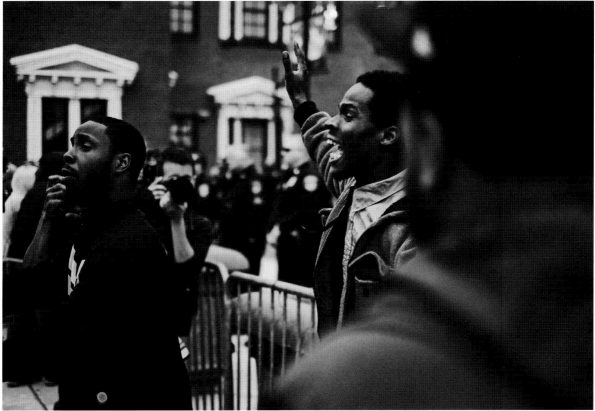

WHAT I KNOW OF JUSTICE

DeRay Mckesson

"No justice, no peace" is a rallying cry heard all over the world. We first yelled it on West Florissant Avenue in Ferguson, Missouri, in August 2014. We shouted it on North Avenue in Baltimore, Maryland. In the stillness of the night, I still hear echoes of this cry and remember that history is closer than I was ever taught in high school. Some understand "No justice, no peace" as a threat. But we know it as a simple statement of fact: there will never be peace—not in our hearts, not in the streets—without justice for those who have paid the ultimate price of police brutality. This call to arms is also a reminder of the work at hand—we are fighting for tangible justice that we can feel, see, touch, taste, and hear. We want justice made real.

I know that the strength to rebuild what we feel is broken often comes from the love of those around us and the space that love creates. I've carried this understanding with me every day that I *lived* the community experience that many people now talk about as an amorphous, theoretical concept. Both of my parents were addicted to drugs during my childhood, and my great-grandmother raised us until I was in middle school. Despite his struggle, I watched my father forge a community with my own eyes almost every day. From him, I learned the power that neighbors had to hold each other together in even the toughest times. We didn't need nonprofit status or government recognition to be there for each other. Instead, we built our communities on trust, strong relationships, and self-built spaces where we could work through our own issues and lean on each other.

Baltimore also taught me that without structural change, intra-community efforts will only go so far. As a teenager, I was a youth orga-

nizer. I saw every type of nonprofit brimming with young, well-meaning workers come into the city when they identified a need and quickly usher themselves out of our city when the need proved more difficult to meet than anticipated. I saw millions of dollars of programming rush into communities, pinned to grand promises about making the city into everything that it had the "potential" to be. But ultimately, these nonprofits were just helping the city tread water, only narrowly keeping the residents from crashing below the waves of poverty. It wasn't until I was older that I realized that money alone was a temporary fix. Programs, at their best, couldn't stem the tide. We needed systemic responses to poverty and violence.

Our work in organizing is rooted in making sure that people ultimately experience justice and have just experiences. Where most people see justice as something reserved for the courtroom, only after people have been wronged, true justice is preventative. A core part of organizing work is to not penalize people for not having the language to describe their experiences, and to get as close to their experiences as possible. Everyone deserves to live in a community where public safety does not depend on over-policing its residents. Everyone deserves to have access to adequate housing and food daily. Youth deserve a quality education whether or not there is a high-quality nonprofit in their neighborhood.

Everything I know about justice—and its absence—I learned in Baltimore. Everything I learned about activism, about fighting for what we know we deserve, about imagining a world that is not yet here but can surely come to be, Balti-more taught me. Baltimore, in all of its tenderness, its laughter, its pain, taught me everything that I know about this world and about what is possible.

"No justice, no peace" in homes ravaged by poverty or plagued by addiction. "No justice, no peace" in communities where violence is still commonplace. "No justice, no peace" in the city of Baltimore, where lessons are hard-earned through struggle and hardship. And until we receive the justice we rightfully deserve, we will continue on with Baltimore's rallying cry.

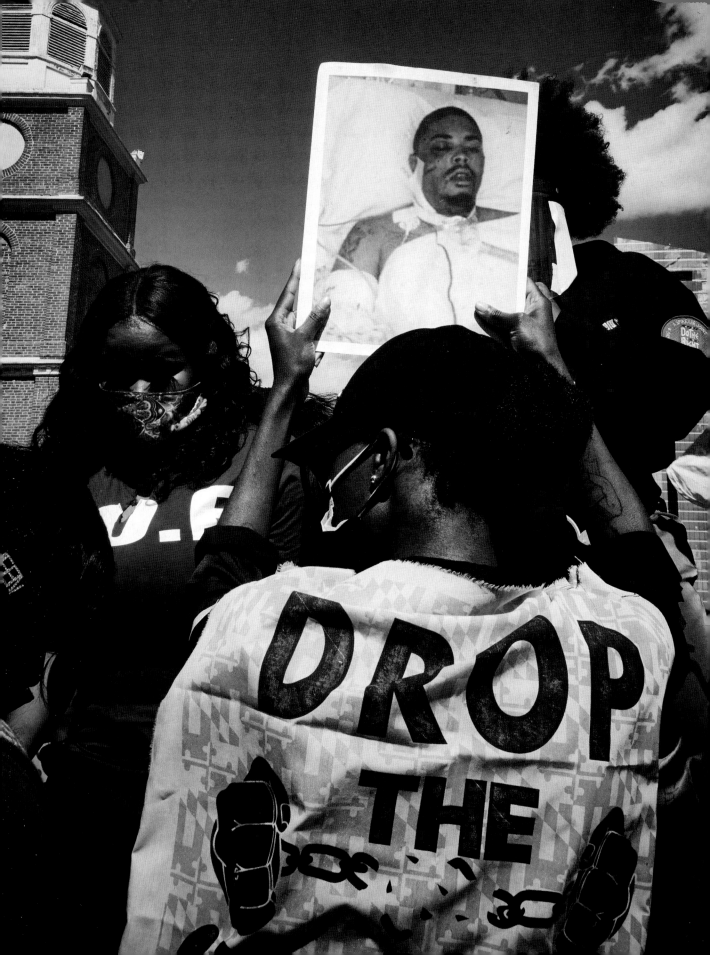

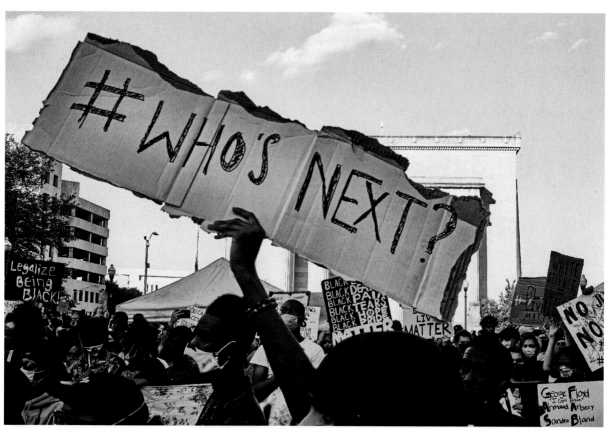

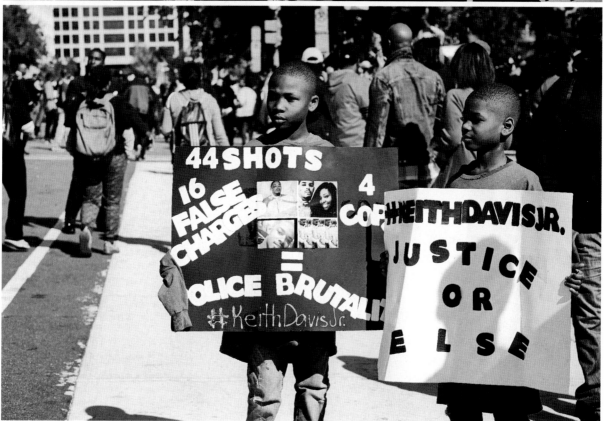

BETWEEN RELAXED SHOULDERS AND RAISED FISTS: AFTER DEREK CHAUVIN'S CONVICTION, WHAT COMES NEXT?

Darnell L. Moore

"Guilty Guilty Guilty."

Now that the judge has read into the public record three counts of guilt in the case of Derek Chauvin, what are we to feel? What are we to think? What are we to do?

Some of us might feel relieved—eyes flooded and faces as wet as rivers as we reflect on the reality that justice has been more of a poetic, aspirational idea than a material fact, for the most part, when it comes to redressing the harm done to Black people in the U.S.

Some of us may feel relieved because the

verdict felt like something akin to justice. So, we cried. We rejoiced. We may have offered up thanks to God, Spirit, Ancestors.

Some of us have depleted our deposit of tears. I wasn't sure if I could shed any more. But I did. And I wasn't sure if my face was wet from relief, or because as I watched in virtual community, some were finally able to breathe a long and collective sigh. Or because the loved ones of George Floyd might now be able to rest in their grief. Or because I imagined them holding one another closely, healing outside the purview of a camera, sleeping well knowing that the person who ended the life of their beloved won't slip out of the confines of a cage like so many other police officers before him (though how can one rest knowing that a guilty charge will never bring back their loved one?). Or perhaps my tears flowed because my sister admitted in our family group chat that she was crying as she watched. And as she watched and cried, I thought about the faith she must summon every time her 16-year-old son, Semaj, leaves the house fully enraptured in his Black youthfulness, only to be read as a threat by some.

I don't know why I cried while watching an officer of the court cuff a former law enforcement officer who killed a Black person, but I know how I felt: like a driver in a vehicle that has been stuck in a traffic jam for so long who, after having waited with impatient patience, finally begins to move ahead with a deep awareness that further along they might come upon traffic yet again. I imagine that is how some of us felt. And I also know that the Black experience in the U.S. has been a vexing and enduring gridlock under the conditions of anti-Black racism and state-perpetrated violence.

So I understood why some folks felt angry still. And rightfully so, because they might recognize that there exists a form of material justice that we have yet to fully imagine and experience. After all, the practices we employ and the tactics that we use are the consequence of the limitations of our moral and spiritual imaginations, shaped in a country where justice looks like punishment, like cages, like cuffs, like policing the police after the police kills one of us, like more violence as a response to violence.

This is why I am suspended between joy and lament, relaxed shoulders and raised fists: because there appear to be few options outside of other possibilities—the greatest of which is George Floyd still being alive. It seems, so acutely, that the only option at our disposal relies on a system that itself needs to be razed. These are complicated thoughts and feelings.

I am buoyed, though, by visions of a just future that we can collectively imagine and build: a time ahead when we no longer seek to end harm by committing harm because that is all that we know to do. And what better time than now?

We have relied on practices that have come to define empty versions of justice and accountability up until now: big-budget law enforcement bodies; big stockpiles of weapons and equipment for said law enforcement; law enforcement's use of Tasers and guns to respond often to the outward symptoms of entrenched

systemic issues; handcuffs; death; jails; and prisons. And while it may seem foolish to demand that we engage in the difficult and complex work of imagining and building toward a more honest version of "justice," we need to realize that our lack of imagining and building will result in more of the regrettable same—more Chauvins arrested, but not enough Chauvins transformed from the inside out.

Imagine, if you can, a world where accountability is evidenced by someone like Chauvin first reckoning with self and their actions. Imagine a world where a sentence might result in someone like Chauvin having to commit to service for an extended period of time in the very community, on the very streets, in which he took George Floyd's life. And imagine if that service was centered on Chauvin's unlearning, contrition, and inner transformation, and not on the use of the service as punishment or saviorism. Imagine a world where Floyd's family and the community could determine the form of restitution that Chauvin would be committed to performing—a type of service that demands he bring life to the place where he once brought about a death. Imagine a world where the *easy* way out of a cage is replaced with the *harder* work of deep accountability, self-reckoning, the seeking of forgiveness, the redressing of harmful systems, and reconciliation. What are we to think and feel and do today, days after the guilty verdict rang out?

Rachel Kushner, writing on the abolitionist thinking and work of scholar and organizer Ruth Wilson Gilmore in *The New York Times Magazine*, offered the following, echoing Gilmore: "Abolition means not just the closing of prisons but the presence, instead, of vital systems of support that many communities lack." This point is instructive.

I have faith in what we might collectively build out of the ruins through which some of us survive, while others are killed. Abolition is the work of building the good that we need in place of the institutions and practices that ail us now.

It is our job, however absurd and inherently unfair, to imagine differently. And we are called, by some vision of a life beyond yet within us, to use that imagination to conjure transformative and just practices. Practices that might ultimately result in Black folks' aliveness and the abolition of all that robs *all* of us of life—whether it be anti-Black racism, or prisons, or police.

I want a future where justice is not violence refashioned as beauty in the form of a cage. And I want a world where Black death is not a requirement for that refashioning. I want a future where two hours or so after we might shed tears because of the conviction of one officer who killed a Black person, we won't discover that a 16-year-old Black girl has been killed by yet another officer. I want a future where I don't carry the weighty anxiety that emerges in the "traffic jam," because I would be able to move about with ease

and without fear that some Black people stuck on the road with me, like my nephew Semaj, won't make it home.

I want a life, a future, a world, however seemingly beyond us, that is more just.

May it be. May it be. May it be.

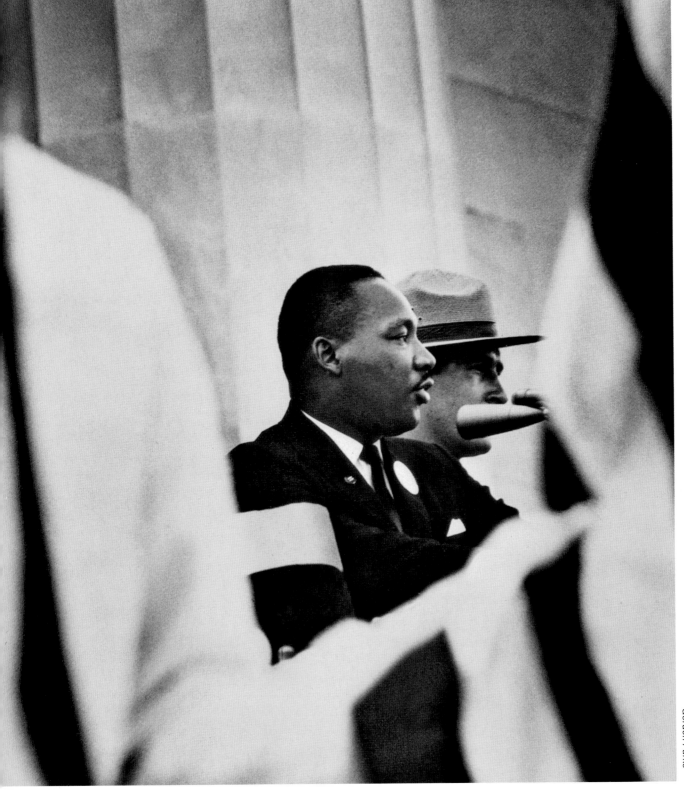

"YES, IT IS TRUE THAT IF THE NEGRO ACCEPTS HIS PLACE, ACCEPTS EXPLOITATION AND INJUSTICE, THERE WILL BE PEACE. BUT IT WOULD BE A PEACE BOILED DOWN TO STAGNANT COMPLACENCY, DEADENING PASSIVITY, AND IF PEACE MEANS THIS, I DON'T WANT PEACE."

—THE REVEREND DR. MARTIN LUTHER KING JR.

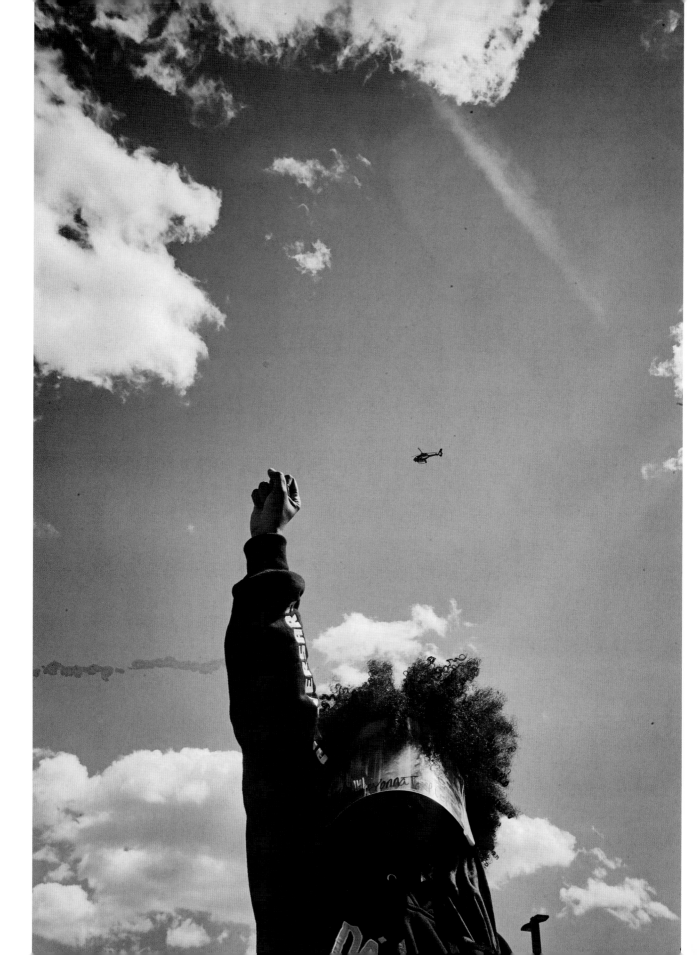

May We All
(A Spell for Alchemists)

Charlene A. Carruthers

May the names
of loved ones taken
fill quilts
sidewalks
and a billion throats singing out in rage.

May our feet and wheels beat pavement
keyboards ignite and create
insatiable appetites for study and knowledge.

May our echoes, water bottles and balled fists
bounce off, break and bang against
monuments of nothingness
after all, we the people, do not own them.

May barriers shatter
leaving luxuries exposed
for all to enjoy.

May we all know
in riot
in rebellion
in uprising and
revolution
there is mess and muck
there are plans and no plans at all
here, where our enemies reward absence
we make presence
and abolition possible.

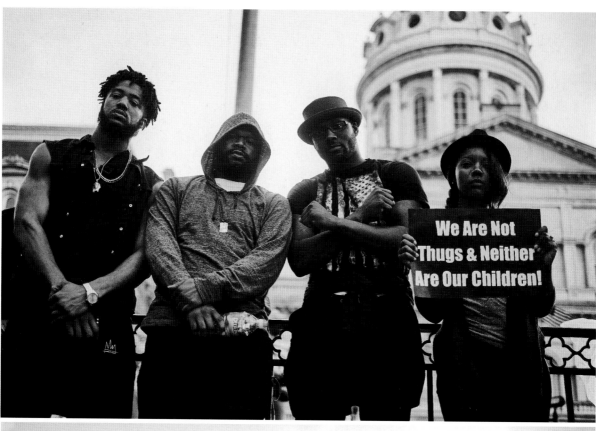

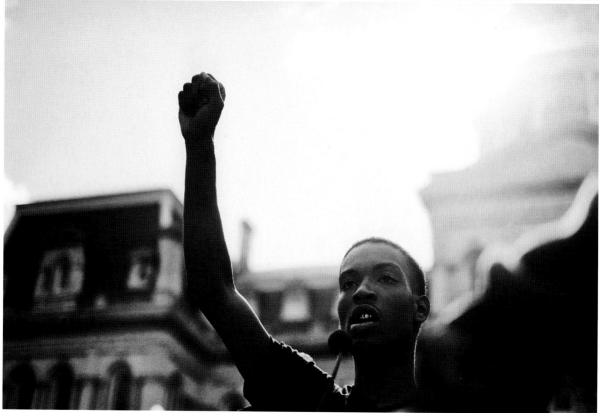

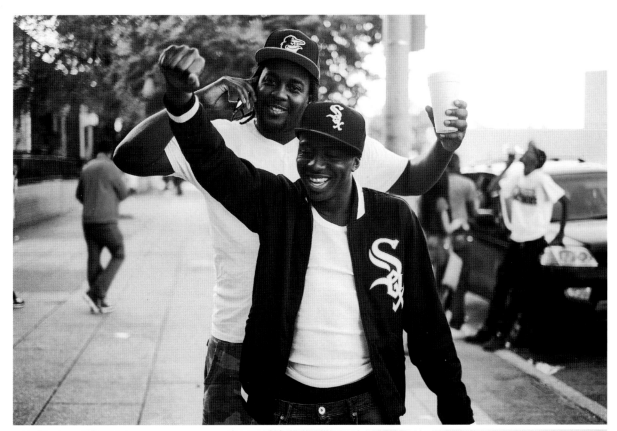

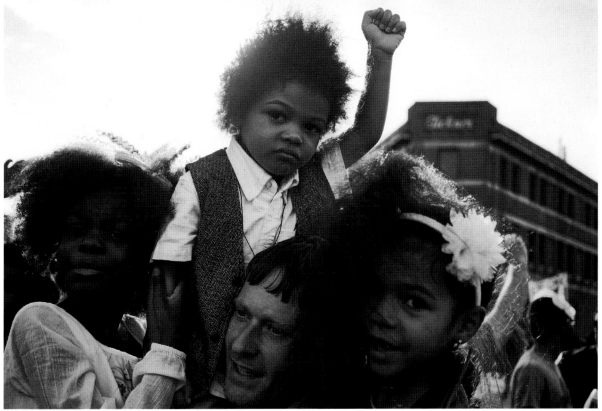

A MOTHER'S SONG

Gail Allen

When my son, Devin, started elementary school in the 1990s, the last thing I expected was that he would face racism. Devin was in first grade when his teacher asked the class, "What did you get for Christmas?" He raised his hand and proudly responded, saying that he got a computer. "It's not nice to lie," his teacher said. Up to the school I went. In that moment, I channeled Ms. Eunice K. Waymon. What a woman! She knew she was something else, something special, so when her singing talent erupted from her soul, she became Ms. Nina Simone. Today, this teacher would meet Ms. Allen.

His teacher was called to the office, where I called her out for her egregious assumption. She apologized, a half-hearted sorry, and promised not to accuse him again. I'll admit, it was comical to watch her uncomfortably apologize to a room of first graders. That embarrassment was just a fraction of what I knew Devin would face throughout his life, and what I had already faced as a single mother.

As Black people, we have the bittersweet blessing of being able to call on our leaders past and present for strength. Ms. Simone spoke her truth and knew her worth in a country that thought nothing of the Black man, much less a Black woman. So naturally, I was in the business of wielding any power I had in my son's favor to keep his hopes from being dashed by well-meaning white women. Ms. Simone's poignant songs resonate in my soul today, as I fight alongside my brilliant son for equality for our people. "You don't have to live next to me / Just give me my equality."

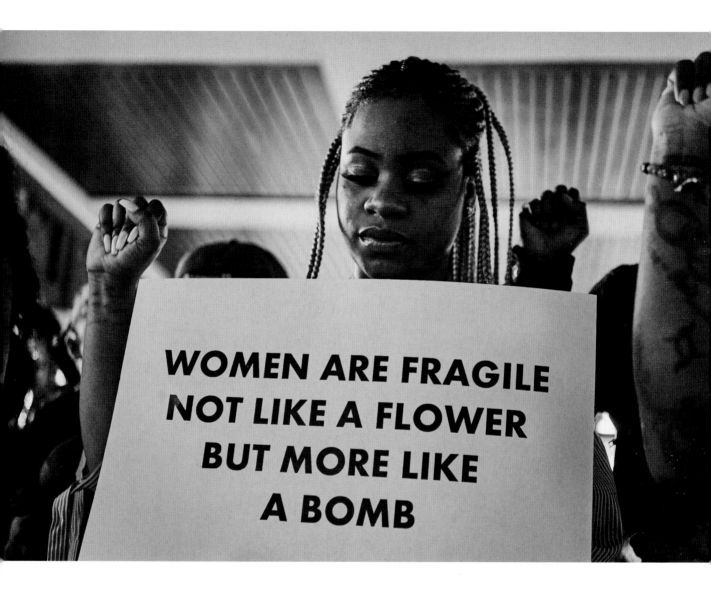

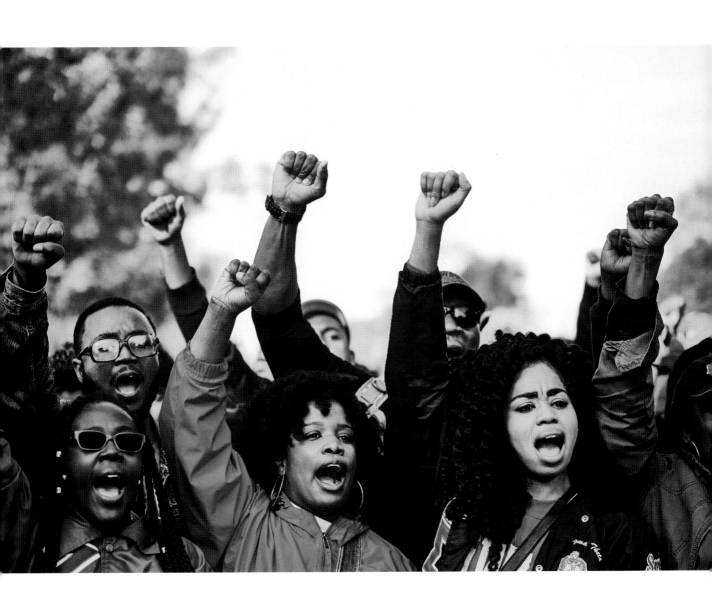

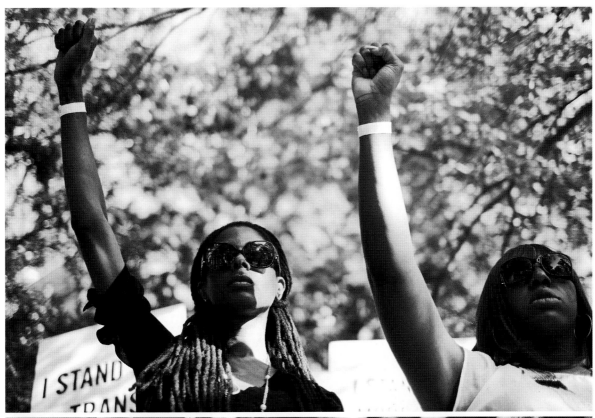

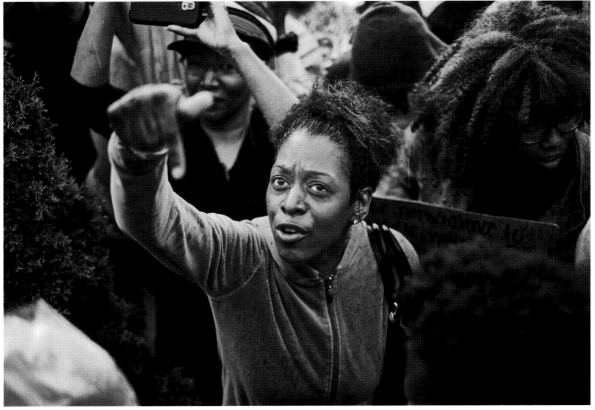

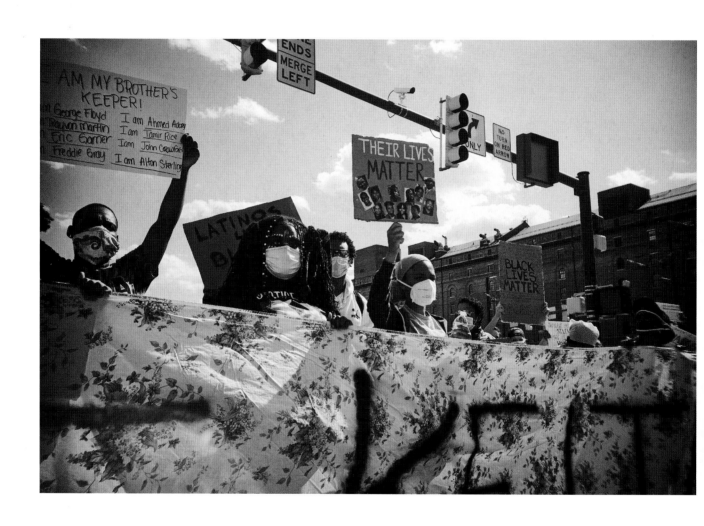

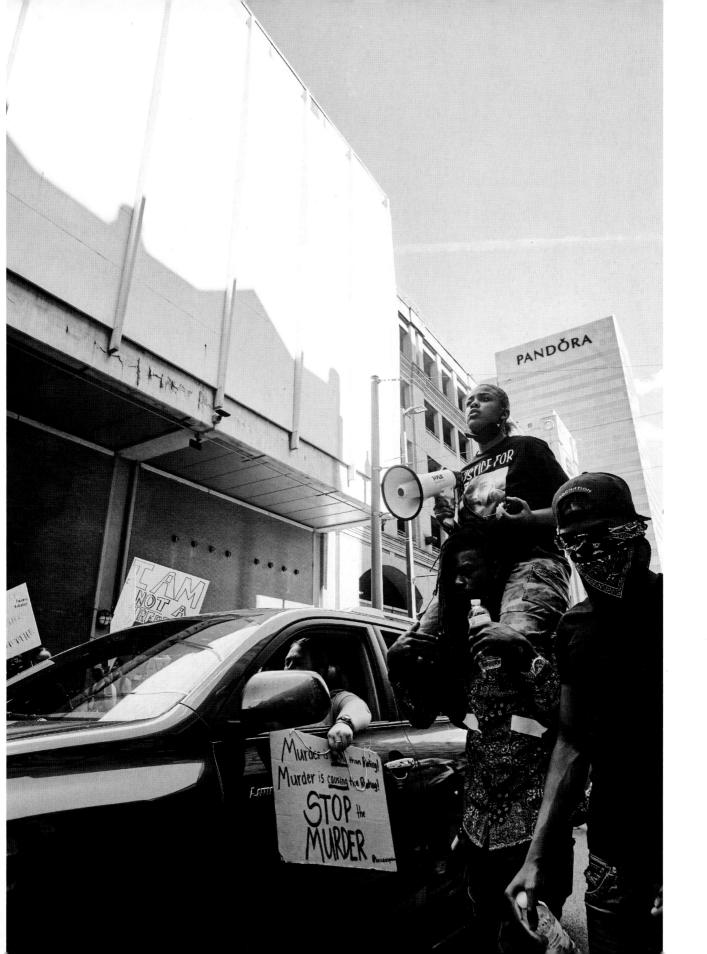

INTERDEPENDENCE AND CHICANA FEMINISM

Carmen Perez

I learned my first lesson in interdependence on the basketball court as a child. "The game is won," our coach would say to our team of elementary schoolers, "not by a star player, but by how we show up for each other on the court." Each member of the team was essential to our victory. No one more important than another. Interdependent. Interdependence—our human need to rely on and uplift one another according to our unique skill sets and learned knowledge—is our strength, not our weakness, as our culture of hyper-independence would like us to believe.

Chicana feminism, which I first encountered in college, added "leader" to my tool kit. My mentor and professor Aída Hurtado taught me that Chicanas like us—women of Indigenous and Mexican American heritage—are able to access our own unique voices through the foundation laid by Black radical feminists. She emphasized seeing ourselves as active members of the liberation struggles of others and showing up in solidarity, especially for Black people, who are targeted for so much oppression and violence.

This solidarity is what I experienced when

I was invited to serve as one of four national co-chairs of the 2017 Women's March on Washington. Together with the other co-chairs, I implemented a model of intersectional feminism at a scale never before seen. The result was the largest single-day protest mobilization in US history, with over four hundred thousand protesters filling the streets of Washington, DC, to call for an end to patriarchy.

These were the dynamics I had learned on the court and in the classroom, playing out in real life. Each organizer contributed within their area of expertise, whether it was twenty-plus years of activism, lessons passed down from elder mentors, or their daily fight for the dignity of our Black and Chicano communities and the women therein.

Still, standing at the helm of a powerful, successful movement as a visible woman of color has made me susceptible to public attacks in and out of organizing spaces. Such attacks are often laced with the same racism and misogyny I organize against, causing lasting trauma. They aim squarely at my confidence and make me want to dim my light to make others feel comfortable. As women of color, we are constantly fighting to be seen and included in feminist movements. Often, when Black and Brown women lead in a movement space, we're seen as one another's competition rather than partners in liberation. Radical white feminists I read frame dialogue in direct opposition to men, who are the gatekeepers of privilege and access for them. This framework leaves out those who experience both racial *and* gendered oppression. On the other hand, Black and Chicana feminists have written about balancing their feminism with the need to show up for their brothers and fathers and sons, who, like women of color, suffer systemic racial oppression and state violence.

I show up so that another young Brown girl can see herself in a leading role. Chicana feminism helps me embrace all the parts of me, broken and brilliant. It helps me love the indigenous features that my ancestors gifted me, which are seldom celebrated as beautiful in this colonial nation. It helps me feel connected to the generations of warrior women who came before me, who never stopped resisting the theft of their land and families. To play it small serves no one, especially not the communities I'm fighting for.

I'm proud of the visibility that political organizing by women of color has gained since the Women's March in 2017. There is now more diversity in organizing spaces, as well as more Black women and women of color elected to state and federal offices, including the first trans women of color to hold office and the first indigenous women in Congress. In 2021, we witnessed Kamala Harris be sworn in as the vice president of the United States—the first Black and Asian woman to hold that office, a child of immigrants, and a graduate of an HBCU.

We are ending the cycle of invisibility so that the next generations can know and feel that their voices are powerful and valuable. Elevating our interdependence allows us to be better leaders, prevent burnout, and move with inclusive practices. The movement is strongest when we are in solidarity with one another, building massive,

decentralized coalitions that can shut down systems of oppression over and over. In doing so, we are shifting culture, changing the narrative, and doing something never done before, all while standing on the shoulders of our elders in the movement who also broke new ground for us.

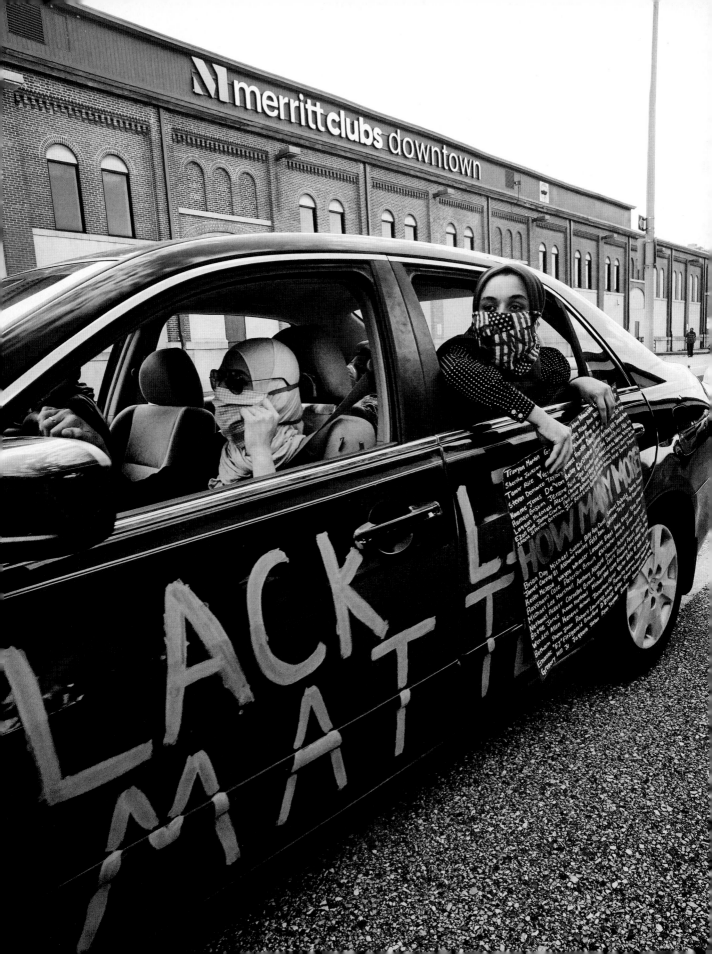

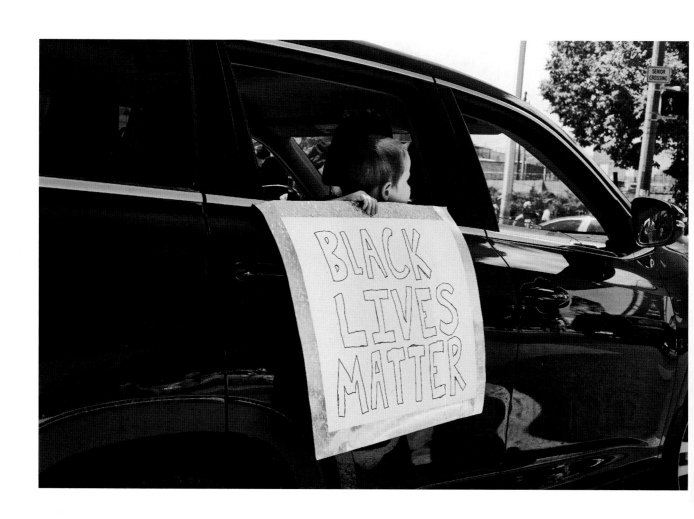

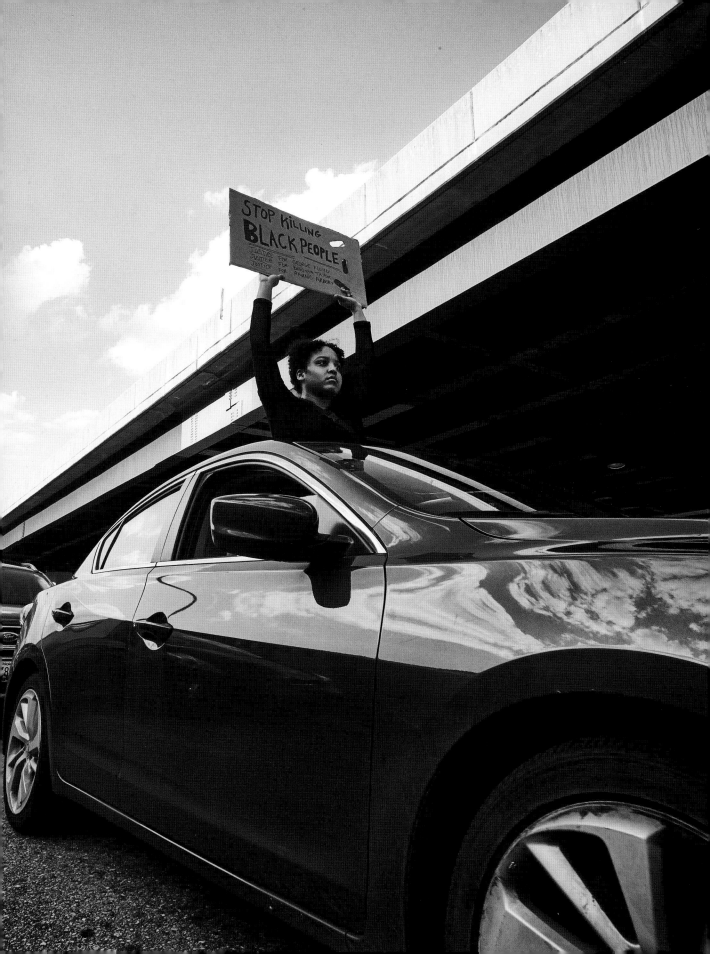

MOVEMENT LAWYERS

Angelo Pinto

We live in a world paralyzed by the magnitude of inequity and oppression. Although the injustices we must overcome may seem insurmountable, the power of diligent individuals who band together has never failed to move the needle of social change forward. Some call them activists; others say protesters, trailblazers, or organizers. Together, neighbors, civil servants, teachers, families, friends, and more form the critical mass that has taken to the streets to make history and thwart the long legacy of white supremacy. This bouquet of front-liners fuels the current engine of global change with its organized discontent and blooms chaos into community.

Now more than ever, movement lawyers navigate the streets of America, aligned with protesters. These are not your traditional lawyers, suited and booted, maneuvering through halls of courthouses. Rather, these movement lawyers bolster the tide, following the tradition of radical attorneys who proposed and nurtured an alternative way of lawyering. They take their skill sets where they are most useful, lending their voices to cries for justice, transforming protest into policy to combat systems of subjugation, and acting as legal observers by functioning as a buffer between protesters and law enforcement.

Today, I stand among the small army of attorneys taking up arms to be an asset in today's movement, carrying on the tradition of radical attorneys. Legal giants like Thurgood Marshall, Chokwe Lumumba, and Soffiyah Elijah, whose advocacy in criminal justice and human rights has built the foundation for the new tomorrows our children will inherit. Beautiful tomorrows forged by the sweat, pain, blood, and struggle of communities walking the worn footpaths of liberation. This rising tide of Black voices, Black protest, and Black power has invigorated a generation and set the movement for Black lives ablaze. The work that we do now is for those who one day will carry the baton across the goal line of freedom.

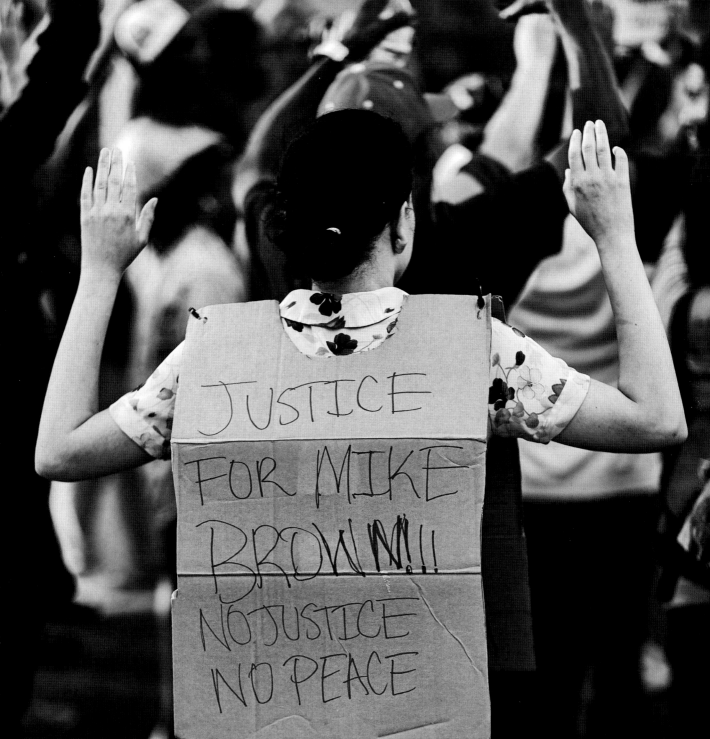

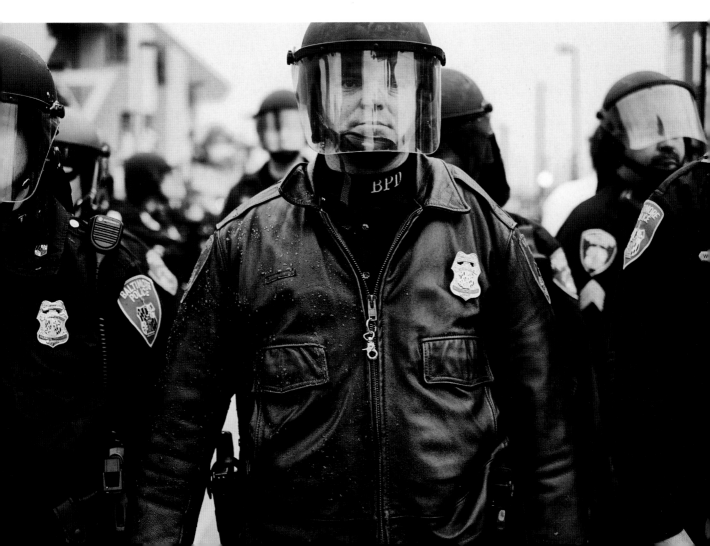

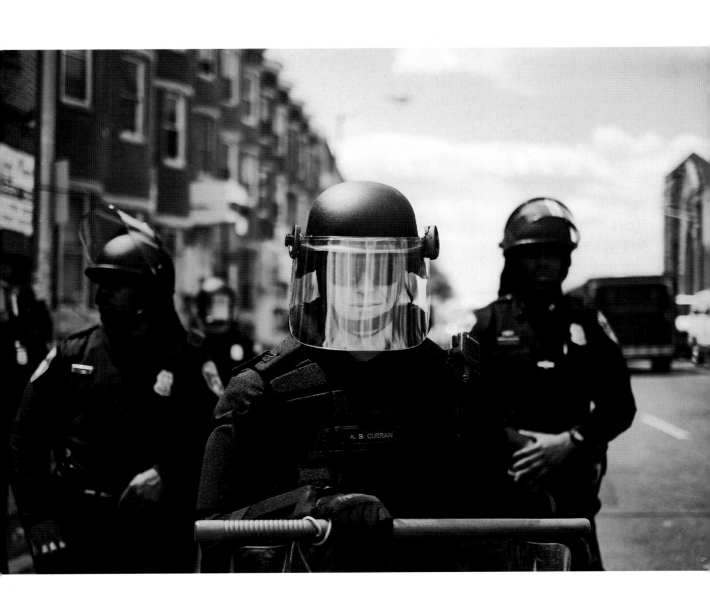

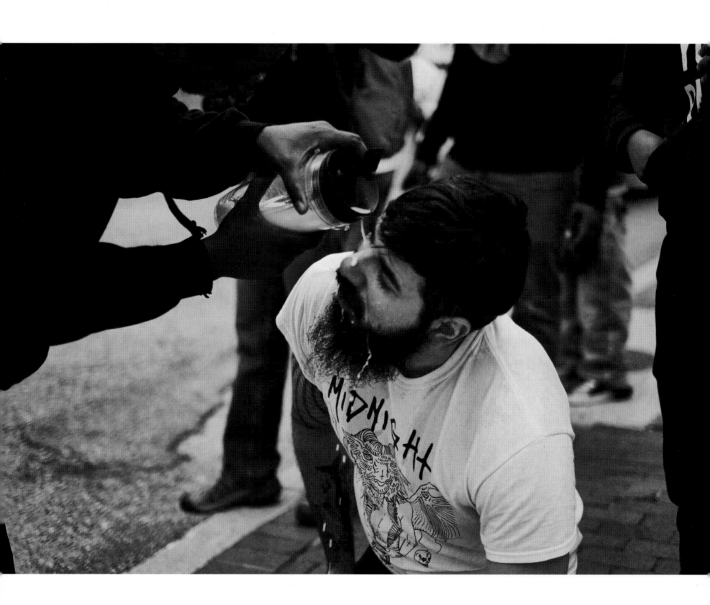

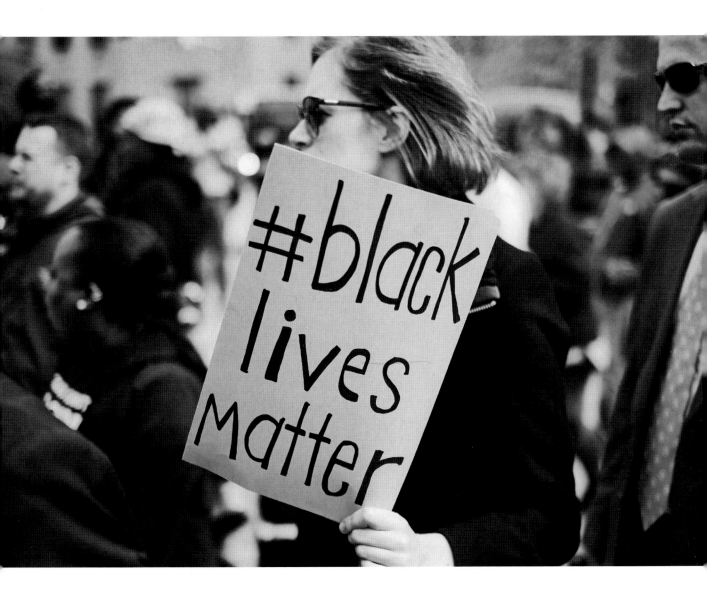

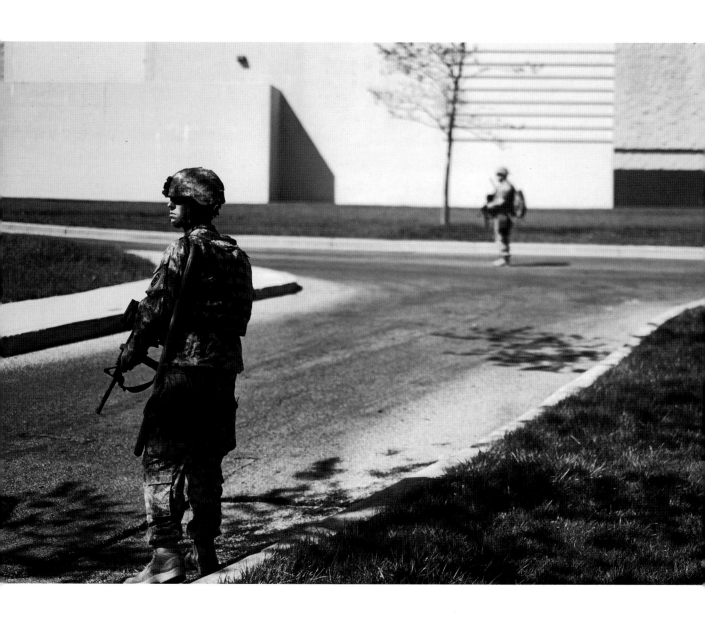

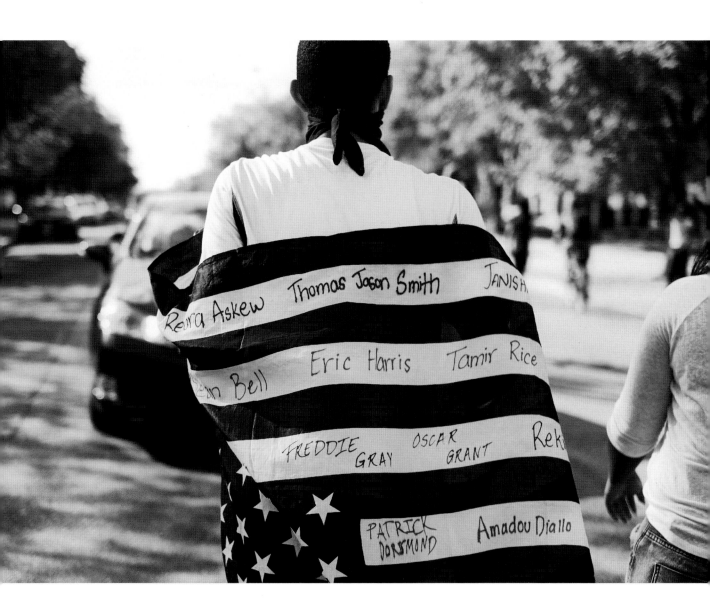

TO RESIST WHITE SUPREMACY

Ruby Hamad

And so it went. Another Black youth shot dead in the street and no-one was brought to justice. New York City was in the grip of a mind-numbing heatwave that July day in 2013 when the news sunk in that George Zimmerman had been acquitted of the murder of 17-year-old Trayvon Martin.

It was a little before 6 pm when I arrived at Union Square where a modest crowd of a few hundred were braving the swelter to do the only thing they could: protest. Make no mistake, that group of diverse—but predominantly Black—Americans was angry.

But this was not the anger that had fueled America's race narrative since the abolition of slavery; a tired narrative that positions Black men as inherently dangerous, aggressive, threatening. This was the anger of a population that felt, unequivocally, that justice had been denied.

Perhaps the writing was already on the wall given it took police six weeks to press charges. Florida authorities initially accepted Zimmerman's account that he'd shot the unarmed teenager in self-defense. It was late at night. Martin was Black. He was wearing a hoodie. Zimmerman felt threatened. Case closed. Six weeks of severe public pressure and media scrutiny led to an arrest, which led to a trial by jury, which led to an acquittal.

Not guilty of second-degree murder. Not guilty of the lesser charge of manslaughter.

Yes, there was anger towards Zimmerman in the streets that day, but the brunt was reserved for a justice system that continues to excuse the extra-judicial killing of young Black men and women. Around the time of this trial, a Black man was killed every 28 hours by police or security guards or vigilantes.

Not only had justice failed but, in the words of one speaker, it was the system itself that had "declared open season on Black people."

At about 7 pm the rally outgrew the small park and took to the streets in an unplanned march. As the crowd snaked its way down Broadway towards Times Square, curious onlookers joined in, turning hundreds into thousands. Supporters clapped from the footpath. Cars honked, not in anger at stalled traffic, but in agreement. Strangers hugged and high-fived each other. People sniffed the whiff of change in the air.

I remember feeling fortunate to be in New York at a time when it seemed that something momentous, something historic was taking place. Speaking to New Yorkers, overhearing snippets of conversations, reading their signs, and listening to their speeches left no doubt that this was a crowd that was interested not in revenge, but in real, honest justice.

But whether justice would heed the call is another matter. "I can't say I have any stock in the system changing," 25-year-old Chris Jackson scoffed when I suggested the possibility. Like so many other Black youth, he felt less safe than ever. "We've never been safe here," his friend Renata Ferdinand added. "This just exemplifies it."

I also felt keenly aware of my outsider, almost voyeur-like status as I tried to document this history for readers back in Australia. Because this story, although familiar in its universal tale depicting the outrage of the marginalized towards the powerful, is also a quintessentially American story. A story of centuries of slavery, segregation, and racial discrimination.

There is an early scene in *42*, the bio-pic about Jackie Robinson, the first Black ballplayer to play in the major league, which foreshadows the remainder of the movie. Robinson, played by the late Chadwick Boseman, is warned by Brooklyn Dodgers executive, Branch Rickey, to prepare for the hostility and aggression he will face from both fans and other athletes.

Rickey asks Robinson a loaded question: does he have the temperament to absorb these taunts without retaliating? The implication is clear: should Robinson react to any provocations, his career would be over. Sure enough, the time comes when a rival team's manager hurls racist obscenities at Robinson as he steps up to the plate. It takes all of Robinson's resolve not to respond, knowing full well that the headlines will overlook the invective to which he was subjected and gleefully focus on the Black man attacking the white opposition.

Robinson learned quickly that any response to racism would be used to "prove" why Black people should not be allowed in white spaces. That this remains a reality for people of color is staggering. Remain polite at all times, stay calm, do not raise your voice or show a hint of aggression. For should you do so, your actions will be interpreted not as evidence of any so-called racism but as a failure of your own character.

The end point of this logic is that it is better to be killed by white supremacy than it is to resist it.

This (il)logic of racism has its roots in slavery. Although institutional slavery is most deeply wedded to the South, in New York's infancy almost half of its households legally owned at least one slave, and a staggering one in five residents were

themselves enslaved. In 1711, the Wall St. slave market was established. This is where Africans came ashore to begin and end the life that should never have been their destiny. It is where they were traded, sold, and abused.

It is where they resisted.

Resistance is an aspect of slavery not often told in the white imagination; the preferred narrative being that of docile, even grateful, infantilized caricatures who meekly accepted their captivity by their racial superiors. To the contrary, the enslaved exhibited clear agency: audacious escapes and rebellions against their white enslavers were not uncommon. History reclaimed itself the day the city protested for Trayvon Martin. Marchers waved placards that likened Stand Your Ground to Jim Crow. There were references to lynching and comparisons to 14-year-old Emmett Till, tortured and beaten to death in 1955, his body discarded in the Tallahatchie River. An all-white, all-male jury needed just one hour to find two white men not guilty of his murder.

The fact it has been reported that Zimmerman admitted to instigating the altercation was not considered relevant to the verdict. It didn't matter that, had Zimmerman followed the instructions of the police dispatcher and not stalked Martin in his car, the young man would still be alive. What did matter—legally—was whether or not Zimmerman felt his life was in danger the moment he pulled the trigger.

That Trayvon feared for his own life was deemed immaterial; the angry Black man narrative does not entertain the possibility of Black innocence. Faced with the pesky fact that Trayvon was un-

armed, the defense astonishingly argued that he had "armed himself with the concrete sidewalk."

After an hour camped in Times Square, the crowd would thin back down to a few hundred and speakers took turns with the megaphone as they decided their next move. Some wanted to go back to Union Square, some to stay put, and still others urged a march on to Harlem, about one hundred blocks to the north, because "that is where we are being killed." At about 10 pm Harlem won out and they soldiered on, chanting, "No justice. No peace."

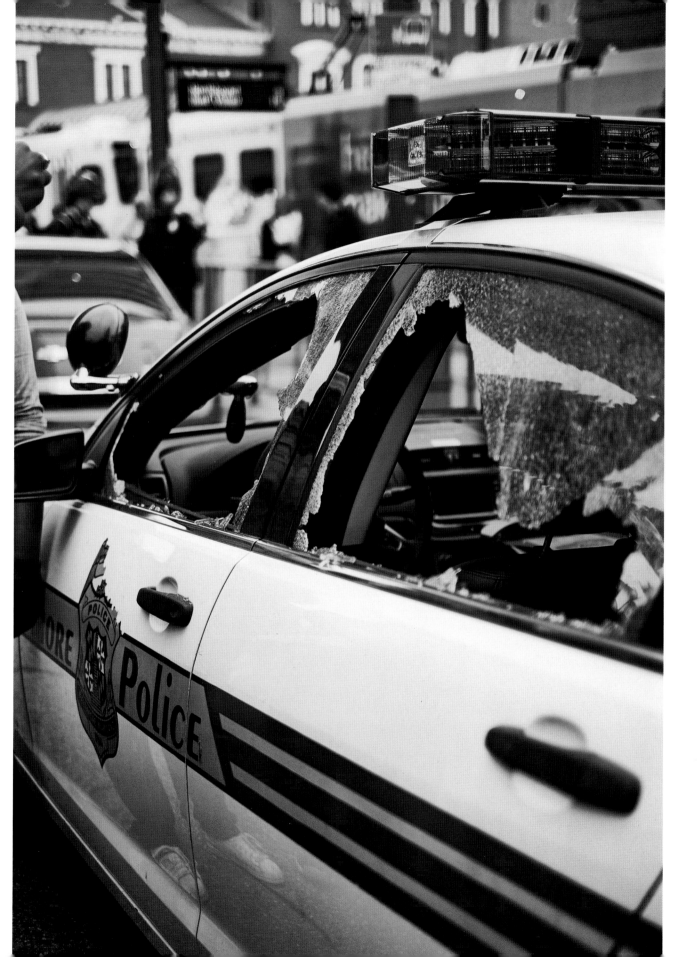

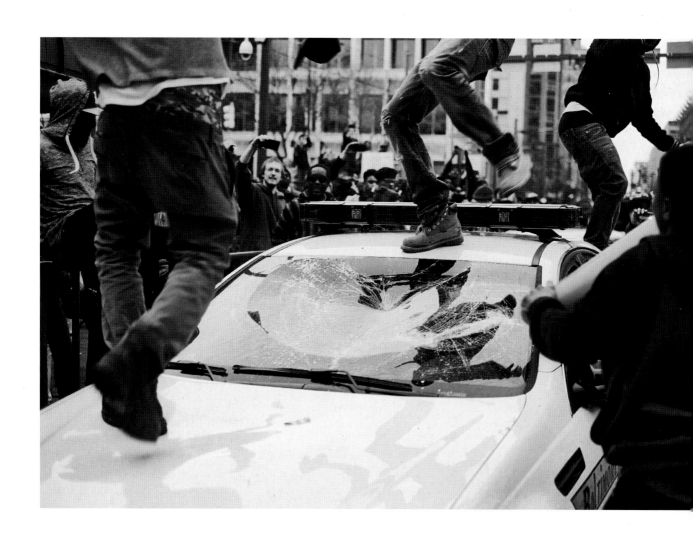

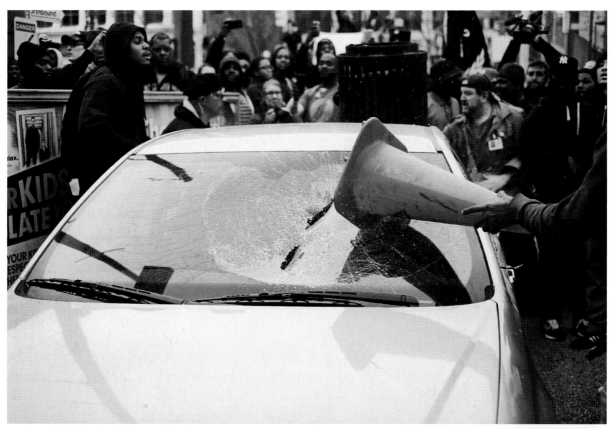

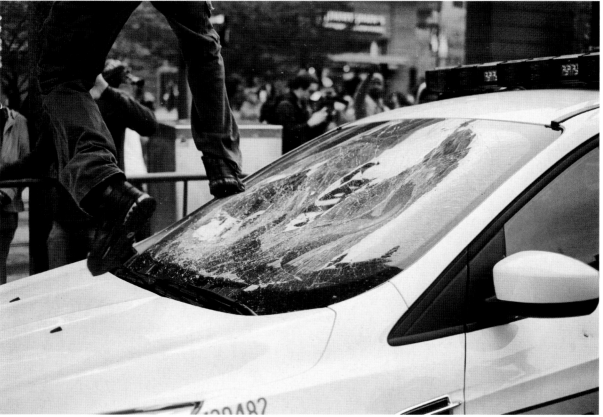

The Moon Wobbling

Jacqueline Woodson

Soon, the moon's gonna wobble the water into rising.

I think I won't live

to see this. I mean, I hope the wobbling inside of me
is enough. *Wobble Wobble*. Black folks know about this:
Jump Up / Jump Back / To the right / To the left
And wobble baby wobble baby wobble baby wobble, running

to the floor when the dj drops the song, their hands in the air
their bodies – doing what the moon's doing now. I never learned this dance
but there's other kinds of Blackness inside of me. Ha!
(You might have just missed that dip into a code switch.) *Wobble*

Bowls of coins scattered throughout

this large house. *Wobble Wobble*. Rolls of bills hidden. Mortgage paid early cuz
I'm ready. Can't touch this! House. Money. Education, aren't I
protected? Ha!

Jump back.

Is it happening yet? Has the water risen to a place
where None of us can breathe?

Not yet.

But the earth's on fire though.
Even in Oregon where my brother in law who lives so close to a guy with guns
our family—all the Black and queer and white-Jewish of us refuse
to visit him. *That* place is burning. Noah – that's the brother in law even though
his sister and I aren't married. Still. Family is family, right? Anyway
Noah's town is on fire and maybe even the crops and crops of weed are burning. How
will we escape now that the ganga's burning? How will
Kush and White Widow take me if all that remains
are a few gummy cubes of gourmet CBD. Take me
to the water's edge I guess even though
I'm an Aquarian –air sign. Baring it on my shoulder but terrified
Still
it's closer now. No *jump back* left in the wobble of the moon
The dance is over. The water

already rising.

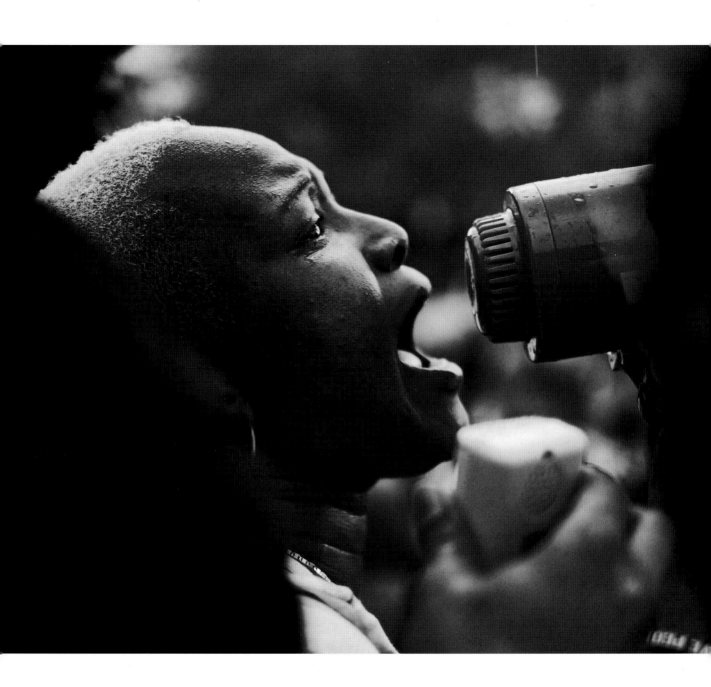

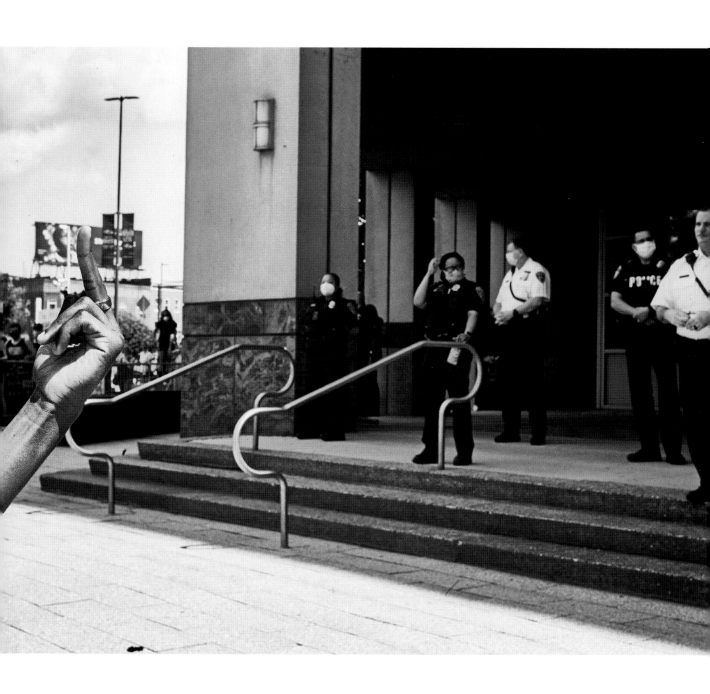

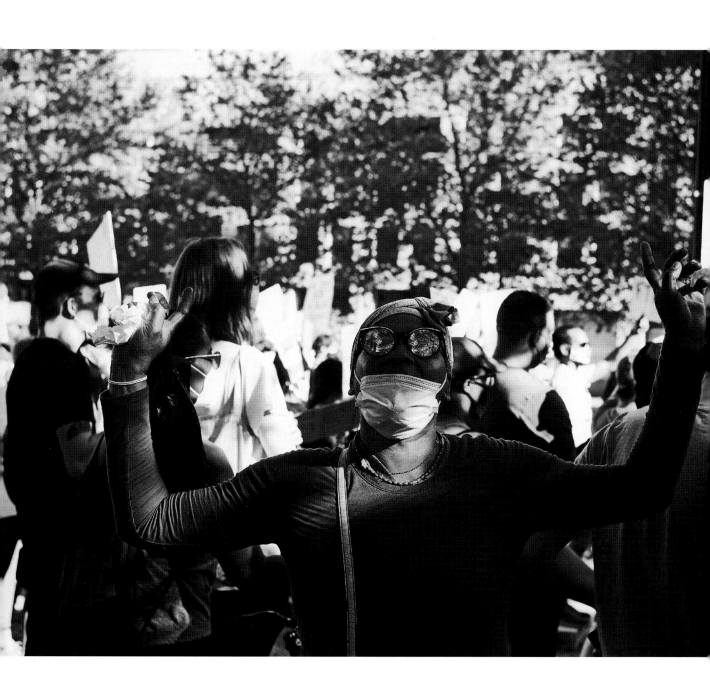

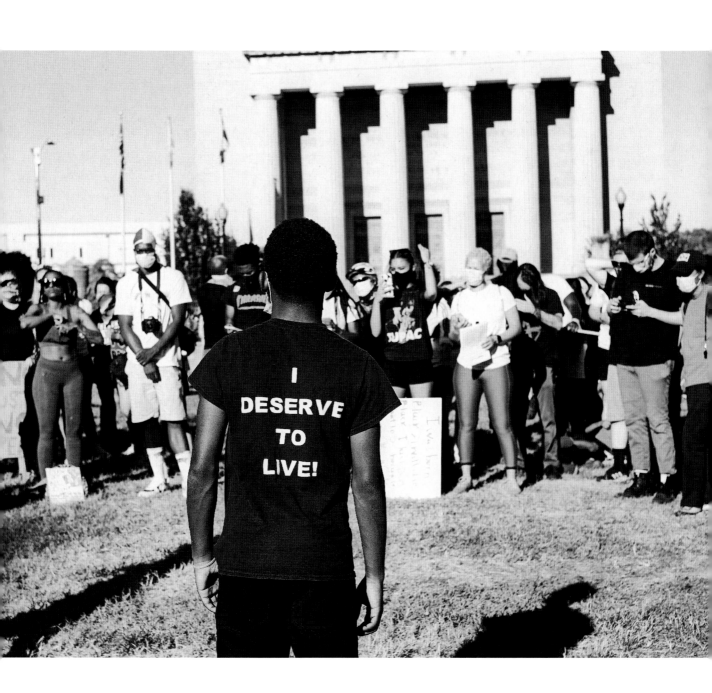

UNCOMFORTABLE CONVERSATIONS WITH A BLACK MAN

Emmanuel Acho

Twelve-year-old me had just finished putting on my school uniform—gray slacks, white button-down, black shoes with white socks—when all of a sudden, I heard crying and screaming from downstairs. I ran down and saw my mother throwing herself into our living room wall. I mean this literally; she was hurling her own body at the wall, shoulder-first. It hurt to see. What was going on? My dad told me that my mom's sister had died in Nigeria. I knew that my mom throwing herself into a wall wasn't going to bring her sister back, and I guessed she knew that, too. It would take me years to process what was really happening. It took me learning about the five stages of grief: denial, anger, bargaining, depression, acceptance (FYI: not everyone goes through all the stages or experiences them in order). What I came to realize was that my mom was experiencing the anger stage of grief and that she didn't know what to do with her anger, so she beat it against a wall.

Have you ever been angry and not known what to do with it? I know it's happened to me. I've learned anger isn't always logical; shoot, it's probably illogical most of the time. And because of that, it's something we often don't know how to express. So what about when this happens not to one person but a group? What about when this happens to a whole lot of black people? When you see people out protesting for George Floyd, or Ahmaud Arbery, or Breonna Taylor, or any of our be-

loved black people who have been murdered, what you're seeing is a group of people who are angry. About police violence, about systemic inequality, about the American dream that isn't yet real for everyone. The protests take a lot of different forms, and even when they get violent—which I don't condone—what's really happening is just like my mother banging her shoulder against the wall.

The scenes of looting and destruction that so often light up the news and certain political rhetoric . . . they're only one end of the spectrum of black responses to the anger and frustration we've felt. An objectively small end at that. The LA protests weren't defined by that group of dudes going down to Melrose any more than a stadium of one hundred thousand football fans is defined by the few who have a drunken brawl in the parking lot.

As always, the words we use matter, and I want to focus on four of them here: protest, riot, rebellion, and massacre. When it comes to the fight against racism in this country, an ongoing question has been who gets to decide which is which, and then how they get to enforce those decisions. You may think the lines are pretty clear: a protest is generally understood as an orderly demonstration; a riot, not so much; a rebellion is an uprising; and a massacre is, well, a massacre—a tragedy of one-sided violence. And yet, as with so much else, it turns out that race has played a big part in how protests are viewed. And policed . . .

Throughout all this history, white privilege has ruled how these conflicts were described. When it was white people instigating the violence, the media, politicians, law enforcement, and eventually historians called what was a massacre a race riot. When black people started to initiate the protests, the media called what was a rebellion a riot, a description meant to portray all white people (citizens, property owners, businesspeople), some of whom were in on the oppression, as persecuted victims of unjustified black anger and hostility, while also making white policing of the situation, no matter how brutal, into a heroic or at least justified response. A note on policing specifically. When race conflicts have been instigated by white people, law enforcement has often responded on a spectrum from doing little to almost nothing, to deputizing other white people to participate, to being participants themselves. When instigated by black people, they have strong-armed protestors, arrested them, killed them. The *Washington Post* reported that eight people were partially blinded during a single day of the recent protests (May 30, 2020) by police tactics like tear gas. Over and over in the aftermath of black rebellion, law enforcement, predominately white law enforcement, has invested in more "law and order"—a decision, you might guess, that tends to make things worse.

What do you see when you look at the Black Lives Matter protests happening all around our world? And why do you see what you see? One thing is for sure: there's still cause for Americans to feel aggrieved by their government. And at no time in recent history has this been more collectively acknowledged than during the protests spurred by the killings of George Floyd, Ahmaud Arbery,

and Breonna Taylor, among others, over the last few months. The *New York Times* estimates that between fifteen and twenty-six million people demonstrated over George Floyd's death in the United States alone, making it the largest demonstration in the history of the country. Some researchers number the protestors at twenty-four million worldwide, which would make it the largest mass protest in history, period. In Minneapolis, the city where Floyd was killed and where this iteration of protests began, protestors trashed a Target and destroyed plenty of other businesses. They burned police cars. Toppled other cars. Defaced buildings. People were beaten. And this kind of violence happened in major cities all over the country. Of course, there were many people engaged in civil disobedience, too, but the more riotous kind brought me back to my mother's anger at her sister's passing, to her banging herself against the wall. As the protests went on, though, I came to realize that even some of this action was coordinated, with solutions in mind. I saw people who'd been protesting showing up at community meetings and giving well-informed speeches about abolishing or defunding the police to reinvest the money in schools and community programs. And I saw that all the noise was actually working.

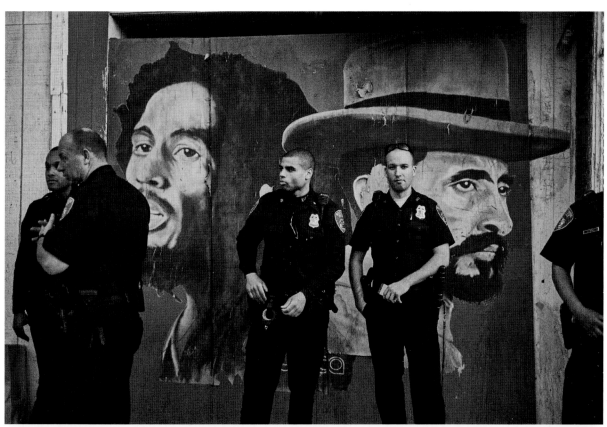

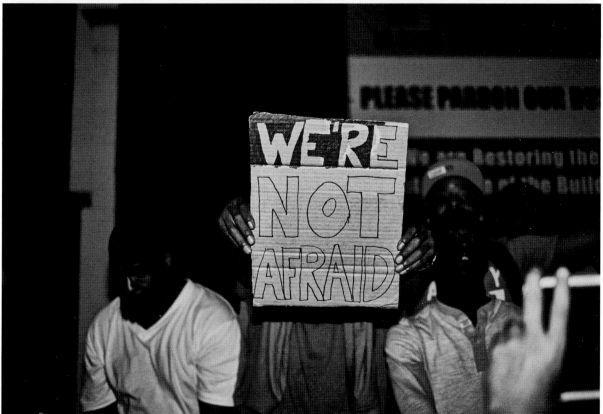

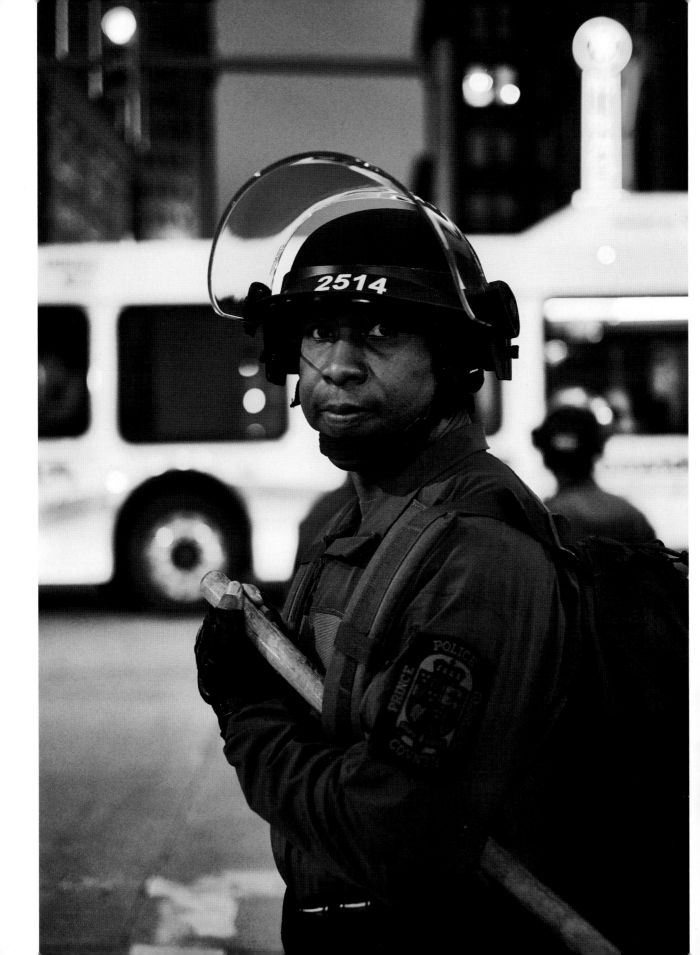

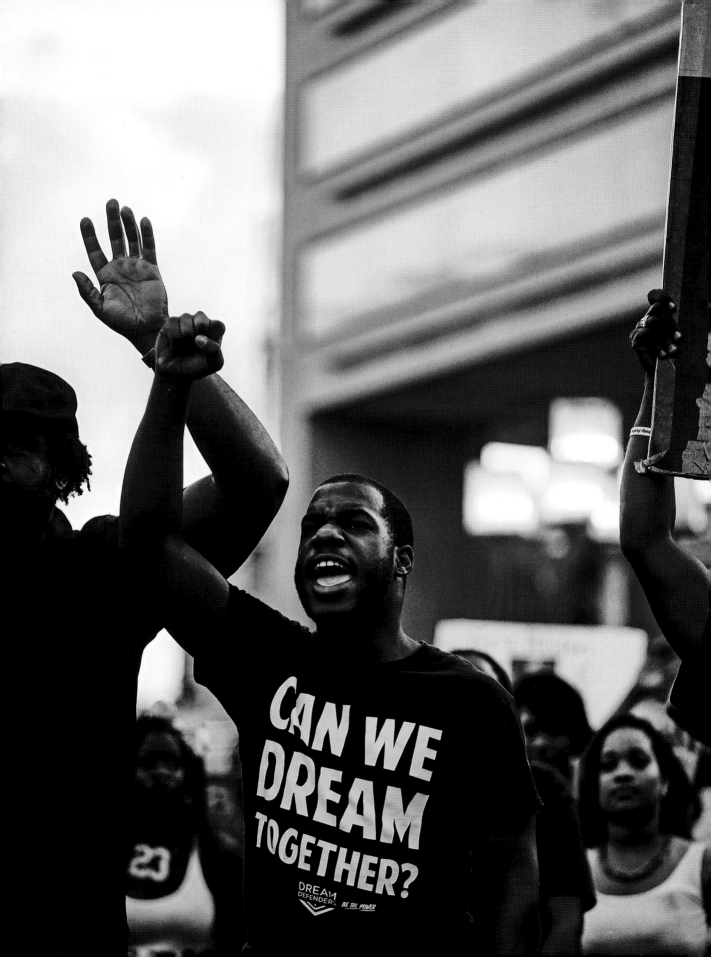

Today in Black History We Honor the Children

Leslé Honoré

We honor the innocent souls

Strange fruit

children like ornaments

swinging in trees

We honor the bullet ridden

The water bloated

The missing

We honor the children

Stolen and enslaved

We honor the eyes

That closed

Soon after blue lights flashed

We honor the lynched

Current

And past

We honor the bombed

The shot

The suffocated

And forgot

We honor the hashtags

The news cycles

Bodies Slain

Then character murder

So blue uniforms

Can walk free

Today we honor the children

The girls tossed and beaten

While still seated in school desks

We honor

LaQuan and Trayvon

Tamir and Rekia

Mike Brown

Today we honor them

The names we know

The litany we don't

The souls we feel

The black babies killed

Emmett then

Emmett

Still

The girls who will never be women

The boys who will never be men

Their only sin

Melanin

Today we honor the children

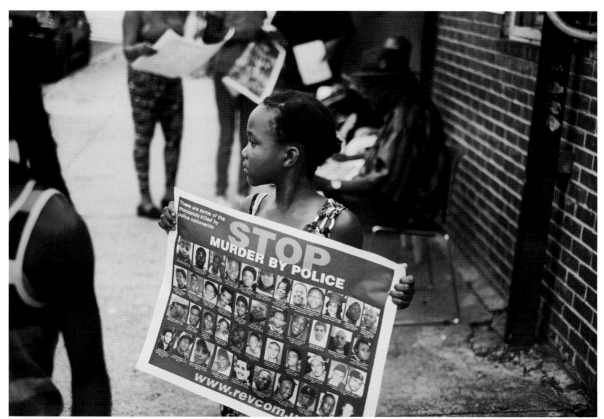

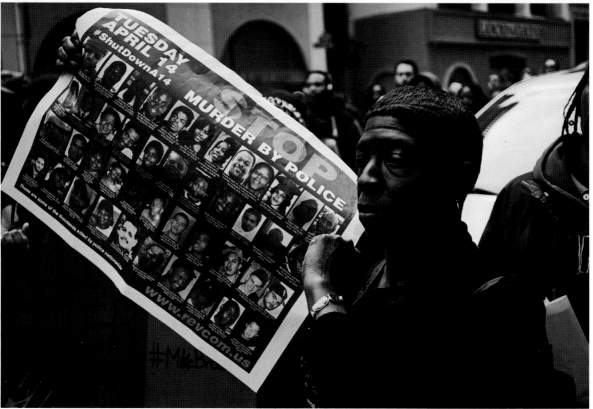

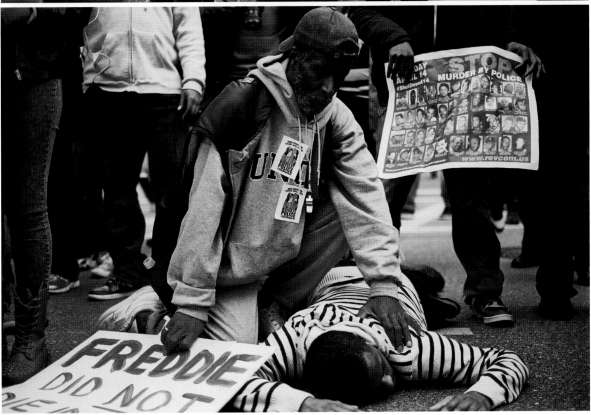

WIDE-EYED PROPHETS WHO SHOWED US A DIFFERENT GOD

W.J. Lofton

Nigel Shelby will be fifteen years old and unbreathing long after you have read these words. His smile brushed into an enduring silence; a mouth impotent of telling us of the God he knew before others rendered his queerness reprehensible. Camika Shelby's son died of suicide on April 18, 2019. Proudly living as an openly gay and Black boy in Huntsville, Alabama, Nigel was confronted with a terrible truth; children replicate the limitations they have witnessed their guardians place on God, which means they will not believe a god exists that not only loves the queer but made him that way. The issue at hand, well, in all of our hands, has always been that we, and in this case in particular, Nigel's classmates and his educators, did not believe that before God formed Nigel in his mother's womb, God knew him. Before this beautiful beaming boy was born, God consecrated him, audaciously appointed him a prophet to the nations. The very real problem is that we expect our prophets to not look like the oppressor but excuse the so-called prophet when he acts like the oppressor; upholding the devaluation of non-cis folk and women, upholding capitalism

and only showing up to protest when the victim looks like them or an outcome that works in their favor. How limited has our worship become? What prophecy smoldered out at the hands of our bigotry? I say "our" hands, because we all have been touched by the malignancy of white supremacy, which, within this country in which we have pledged our allegiance, has forced us into the worship of a hateful, small, and spiteful god. A god whose own imagination will lead us to destruction by way of tropes that speak of freedom, lacking the true divinity to get us there. There can be no revolution without bodies present to testify to the realities of this world and of God's love—Black bodies, queer bodies, differently abled bodies, women bodies, non-binary bodies, trans bodies, and every(body) part of the collective working to dismantle, as Resmaa Menakem coined, white body supremacy. By this point, Nigel will have been gone a few more minutes than he already was when your mouth, or your mind's mouth, first opened to read these words, and at this very moment there is another Black body at risk of being reduced to a slow-jogging whisper. What are you going to do about it? What strength will you ask God to give you? And if so granted that miracle to be able to do something, will you use a pluralistic lens to approach the fire? Will you see that queer rights are Black rights and Black rights must include women and the dreaming must unfold as the greatest quilt we've ever seen? The very survival and dignity of children such as Nigel, ones who show us a different God—an abolitionist Creator—depends on our solidarity. As Black folks who follow in the tradition of June Jordan, Bayard Rustin, Toni Morrison, James Baldwin, and so many more, we must continue to bear witness to one another. To never believe the lie this country has tried to convince us of: the lie that God hates us. No, we must remember the sprightly and wide-eyed prophets who showed us a different God, ones who dwelled in liberation and sought to break the chains of those who still knelt in the dark places. Nigel Shelby was courageous enough to not believe that all he could be was straight, white, and boring. We must hold that same courage now.

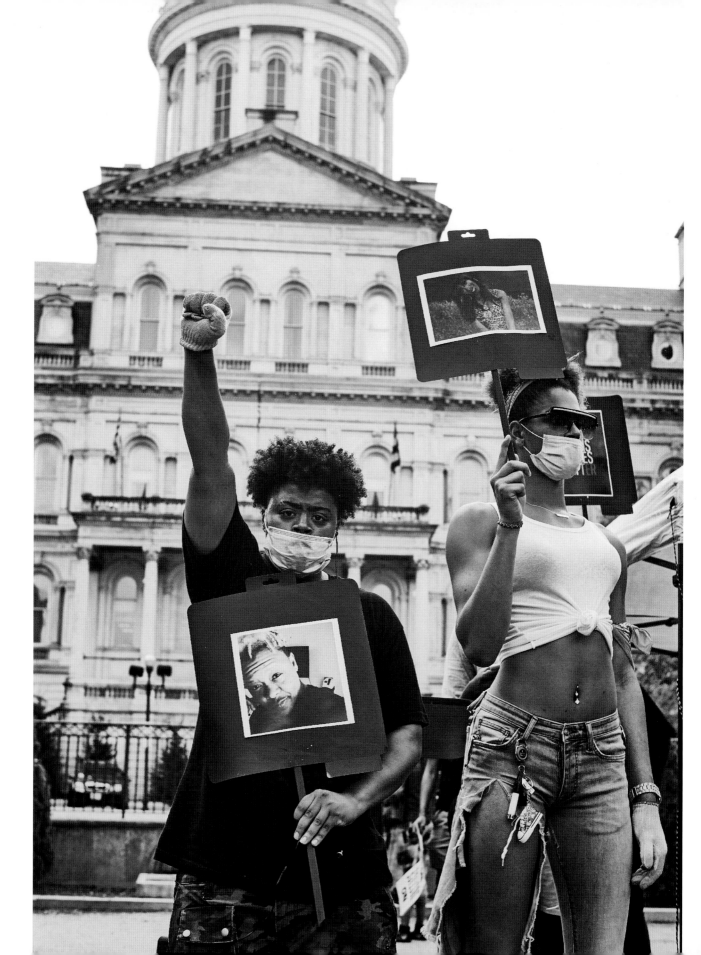

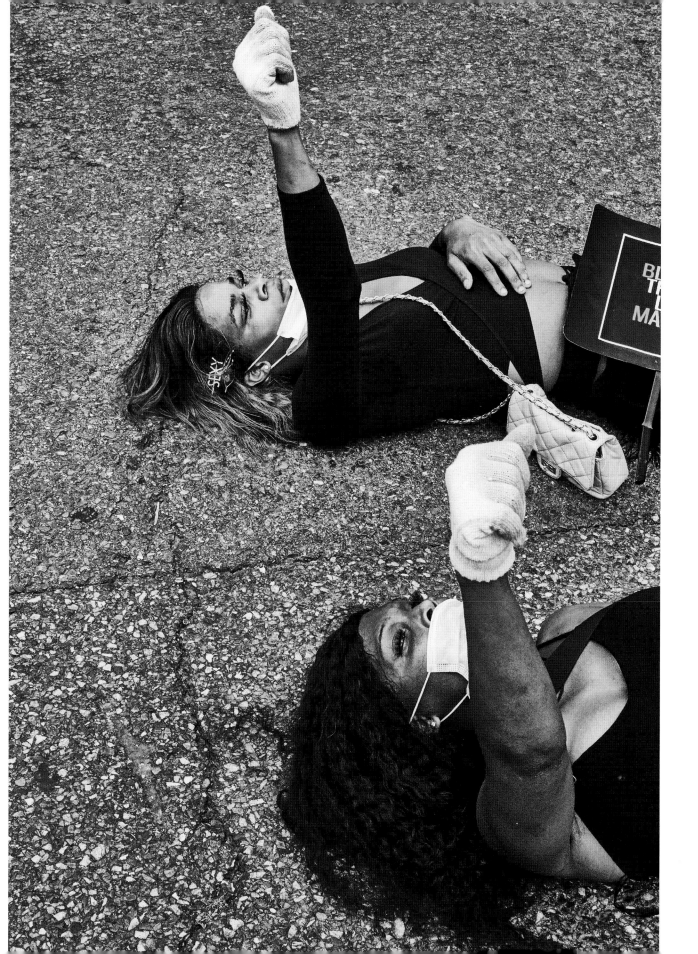

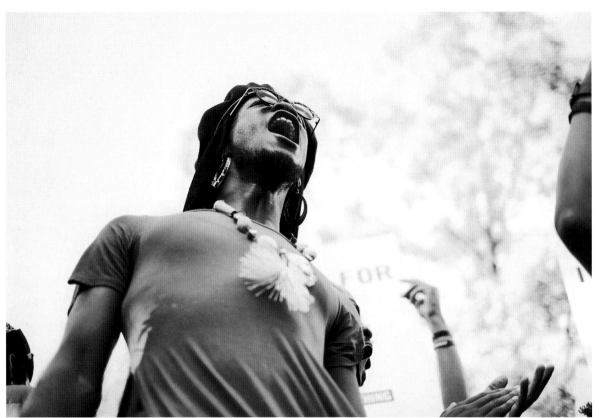

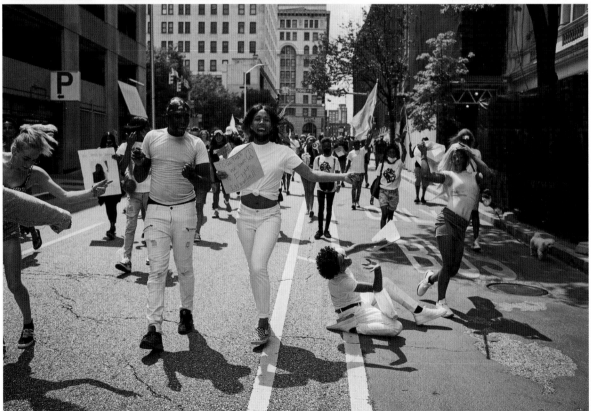

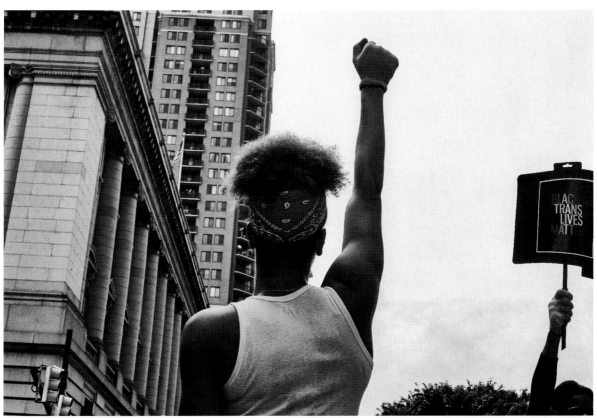

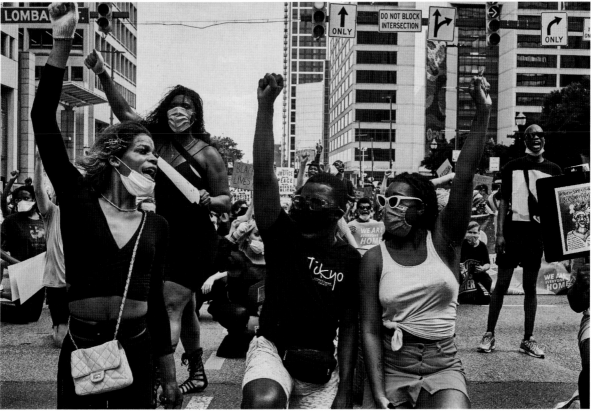

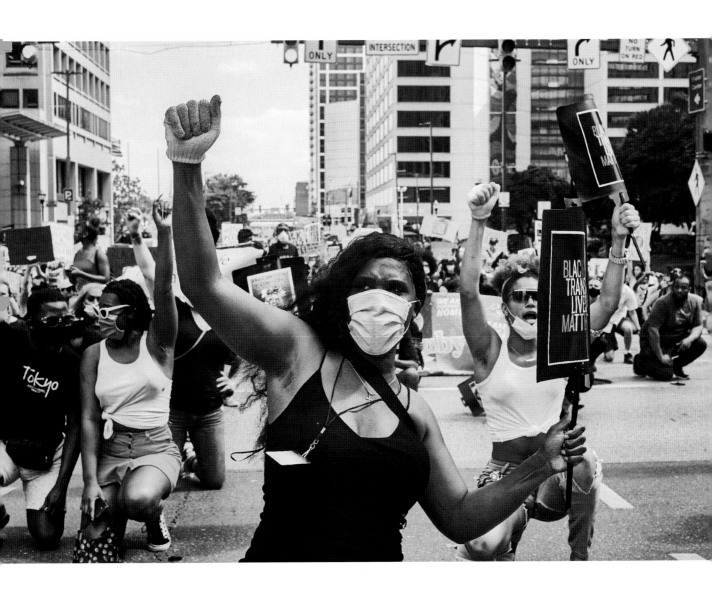

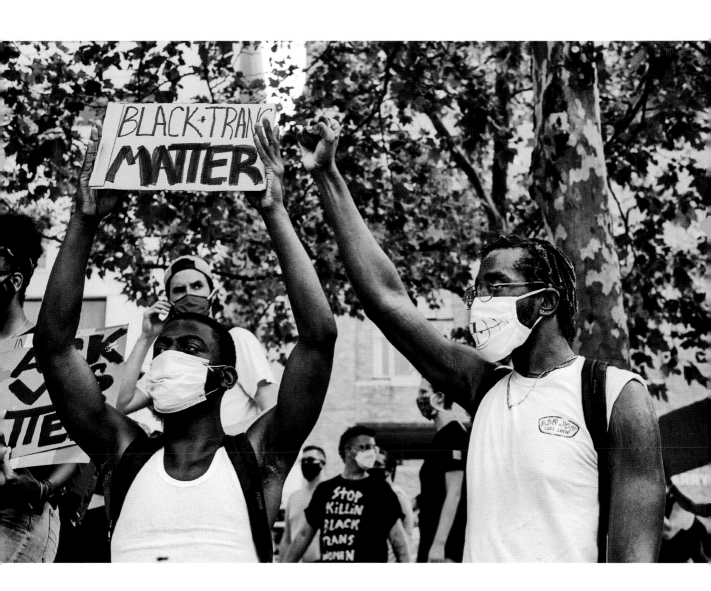

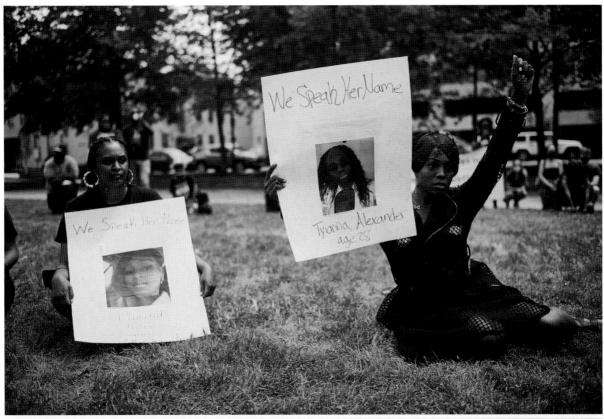

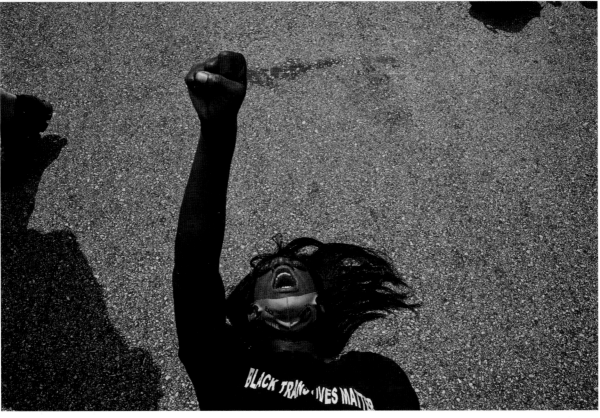

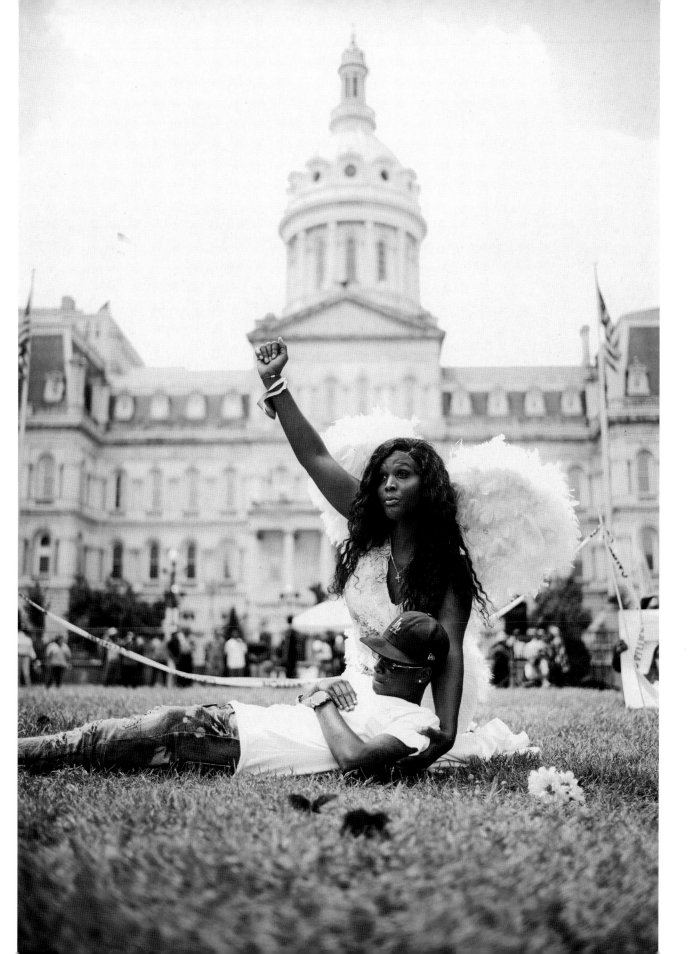

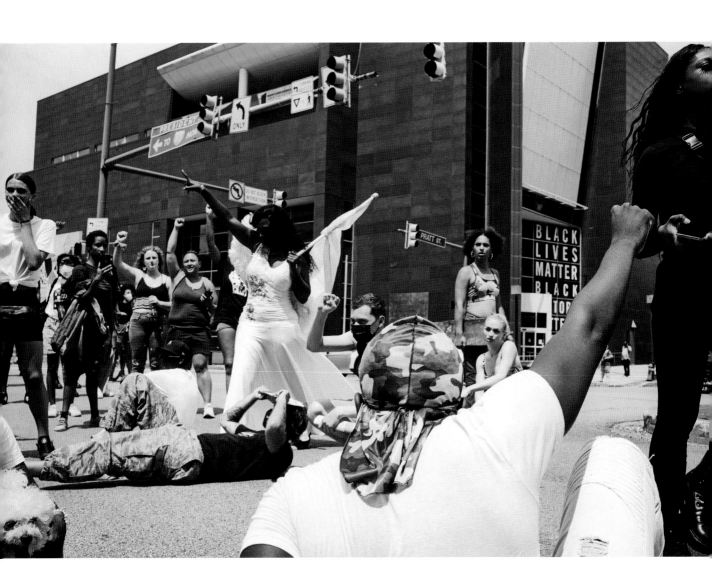

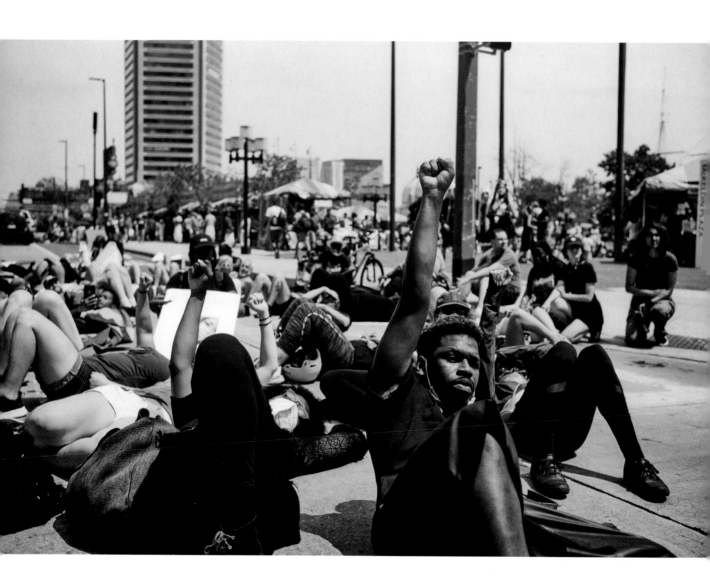

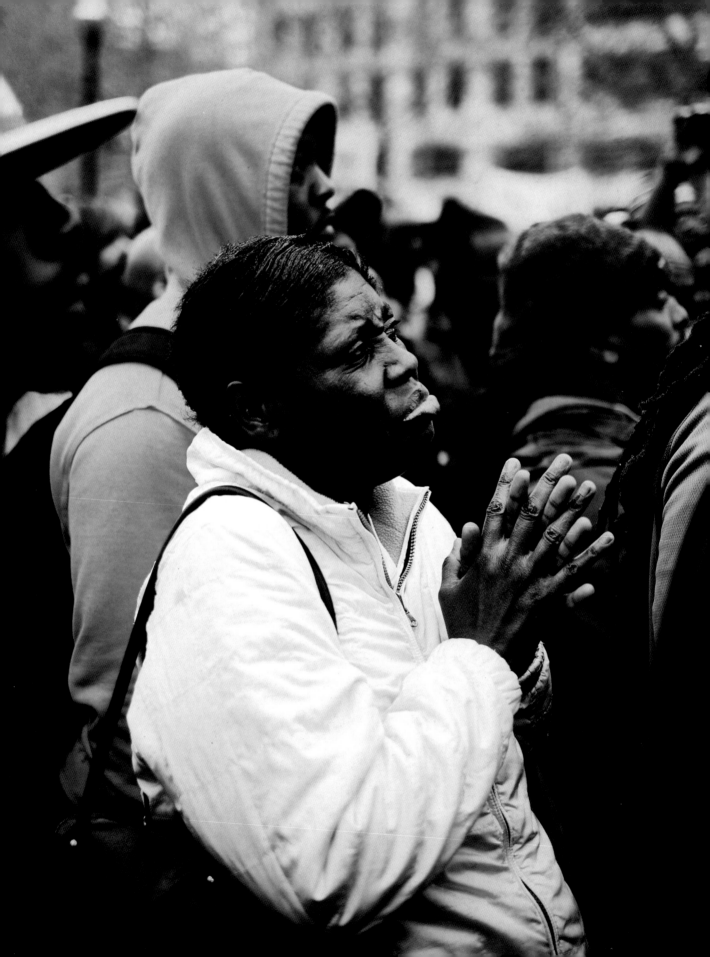

"WE **MUST** SUPPORT THE STRONG. WE **MUST** GIVE COURAGE TO THE TIMID. WE **MUST** REMIND THE INDIFFERENT, AND WE **MUST** WARN THE OPPOSED."

—WHITNEY M. YOUNG JR.

VIRAL EXECUTIONS

Kondwani Fidel

Not long ago, I was walking down the street in Baltimore, and as I passed the Amtrak train station, a huge electronic billboard caught my eye. The billboard read, "George Floyd," with a heart scribbled at the top of it. Not in the mood to tap into the grief, I checked out the Pattern app, thinking that it would take my mind off the current state of the world. A friend had told me that the app inspired consciousness and empathy through the zodiac signs. But when I opened it up, as soon as the opening animation subsided, a Black Lives Matter solidarity statement supporting victims of police brutality popped up. I closed my phone and stuffed it back in my pocket. After another block or so, I pulled my phone out again to listen to some music for a little therapy. I opened the Apple Music app to find a statement directing users to a single streaming station that celebrated what they called "the best in Black music." I shut down that app and logged on to Twitter, which showed me a steady stream of tweets and videos of police brutality, racial injustices, and RIP posts for people who had lost loved ones to gun violence. My entire day was filled by these constant reminders of what we face as Black people in this country.

Unlike on apps, we can't hit the block button in real life. We can't change the settings of our lives to "private" when crooked cops disguised as public servants terrorize us daily. I don't need a reminder of these harsh realities. I live them. Due to these realities, the Thanksgiving table shrinks in size every year. The slain don't pull up to the cookouts anymore. Friend after friend in our group photos vanishes. They aren't there to yell when I walk across the stage at graduation. There are numbers saved in my phone that will never ping again.

Even after I log off my phone, as I walk through life as a Black man, I can't help but stay alert. I don't want to become the protagonist of a video scene on everyone's pocket-sized screens. With these viral videos—modern-day

lynchings—giving Black people constant reminders of what our public execution could look like, what can a safe space look like for me, for us?

If we have to use videos and images to spread awareness about discrimination against Black lives, let them be ones that further the discussion and knowledge about the injustices. Instead of serving the same song on repeat, let's press play on what's next. Propaganda is one of America's oldest and most useful tools to maintain racial conformity. Ida B. Wells, journalist and researcher of the nineteenth and twentieth centuries, understood that perfectly. Wells, a Black woman who was born enslaved, documented the horrifying practice of Black lynchings and white mob violence in the late 1890s. Using methods we now dub as "field journalism," she wrote articles and comprehensive pamphlets that painted a full picture of the horrors of lynching. She even traveled to England to showcase her findings in images and statistics. She validated the experience of Black Americans while educating white people around the world on their complicity. We could all be pulling a page from Wells' book. She was strategic, empathetic, and effective, taking care not to retraumatize her people by pushing their brutal realities back into their faces. That kind of care adds longevity to the movement.

To create a long-standing impact, we must exercise conscientiousness around our own awareness. We must use our voices to break cycles of trauma, rather than create new ones. We must remain steadfast and resolute in dialogue and action to ensure that the violence against Black people ends.

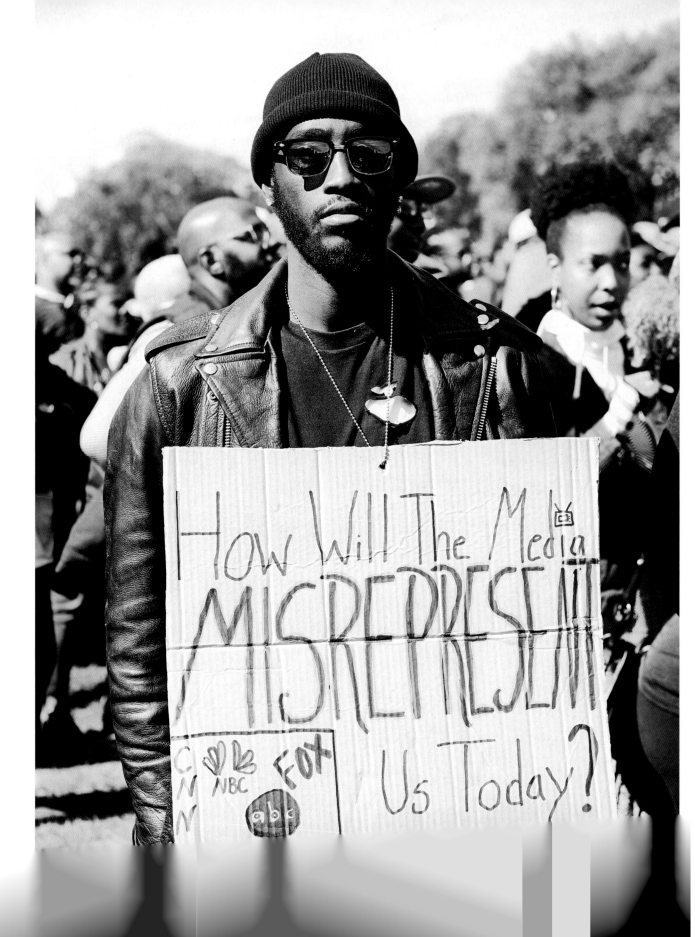

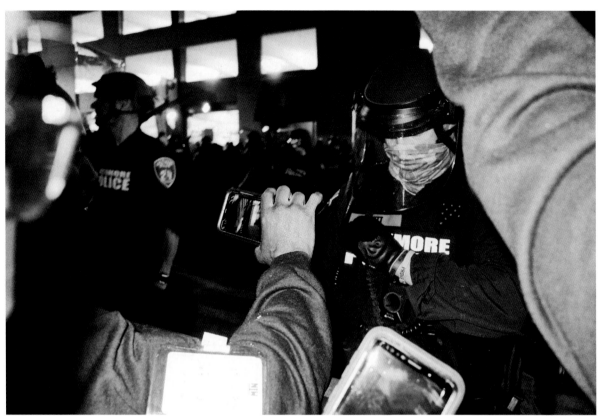

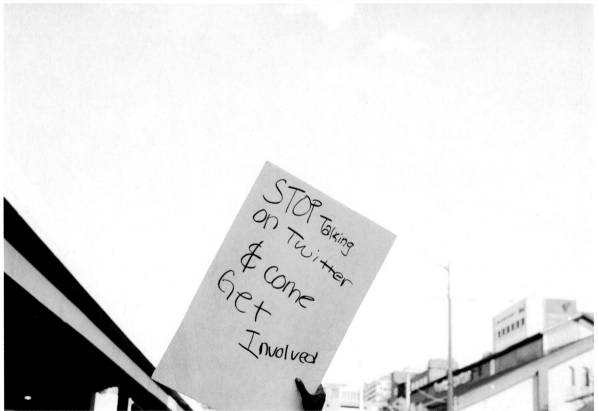

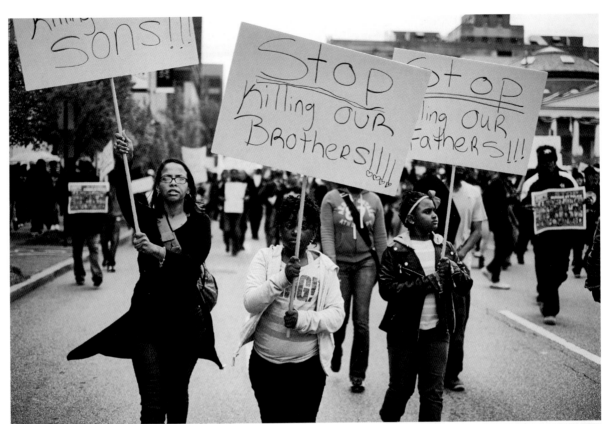

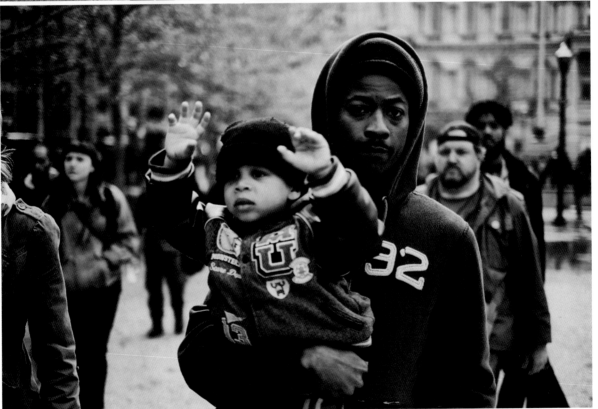

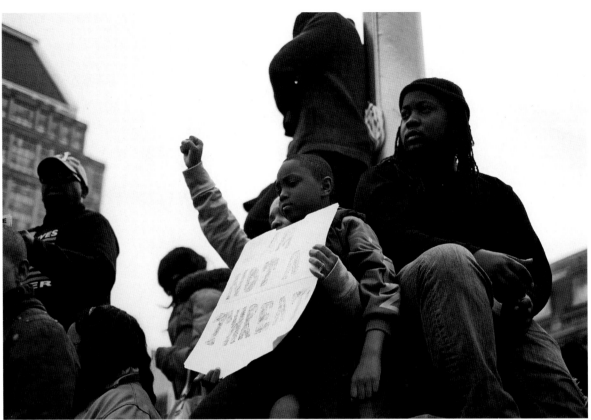

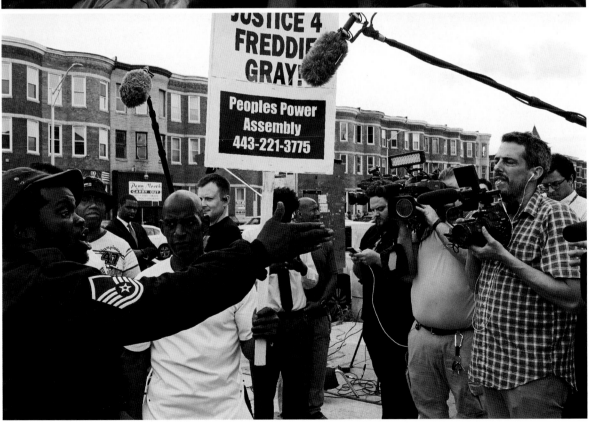

The Problem with Pandemics in America

Wallace Lane

The problem with pandemics in America
are the differences.
The tale of two stories untold
not based on distances.
The cruddy Constitution and all the crime
in those sentences.
The wicked white man who wrote
and all his witnesses.
The same government who lynched us
It's no coincidence.
Pumped us and destroyed us with poison
and carcinogens.
That sin then dictates our health,
down to our penmanship.
And further separates us as poor
from those with privileges.
And after they avoid and destroy,
they exploit our differences.
And wonder why we tired and riot
this country's wickedness.
The problem with pandemics is always,
the subtle differences.
Generational gaps with blacks

That's where collision is.
First they took our freedom
and turned us into the living dead.
Made a profit off cotton and slavery
as the businessmen.
Built the nation then cut the shackles
with no percentages.
Raped of us reparation and favors
said fuck the dividends.
Segregation in legislation
pain was significant.
Mass incarceration new obligation

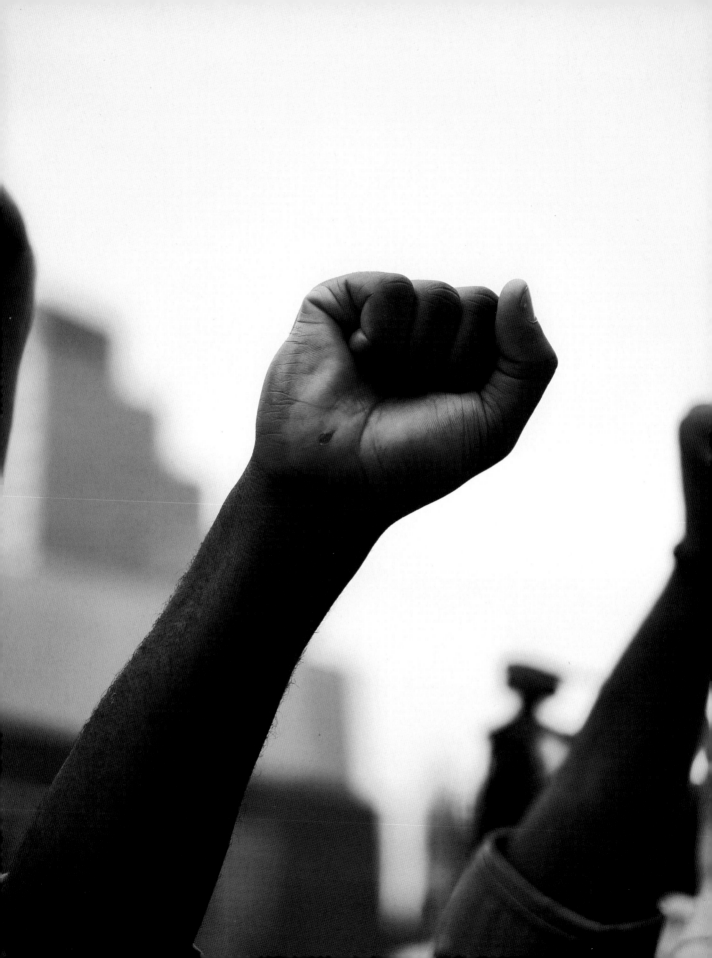

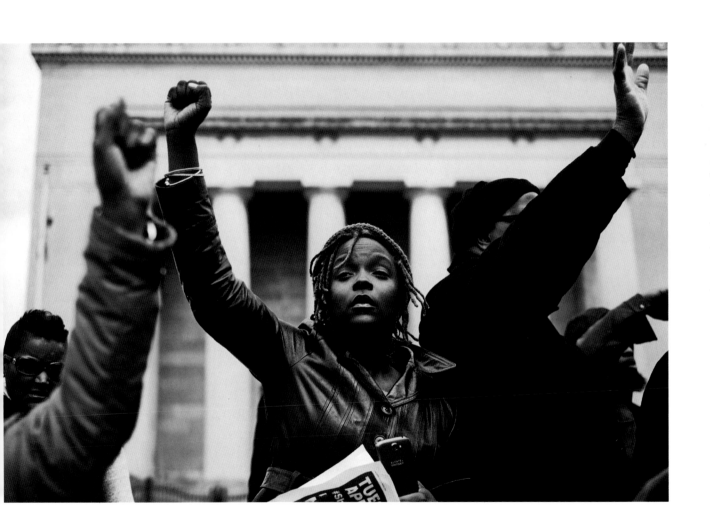

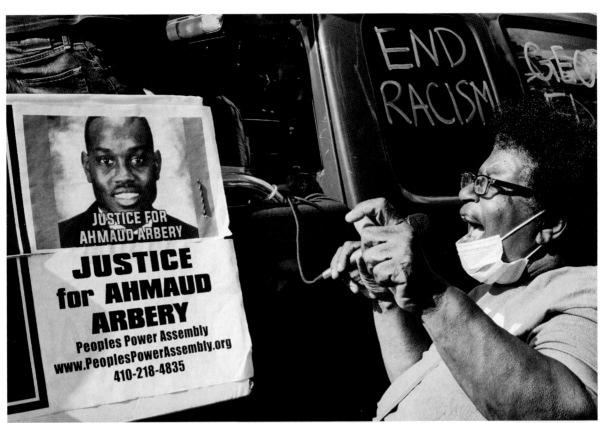

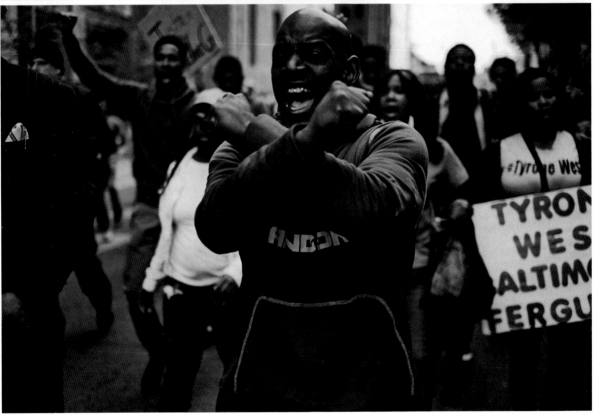

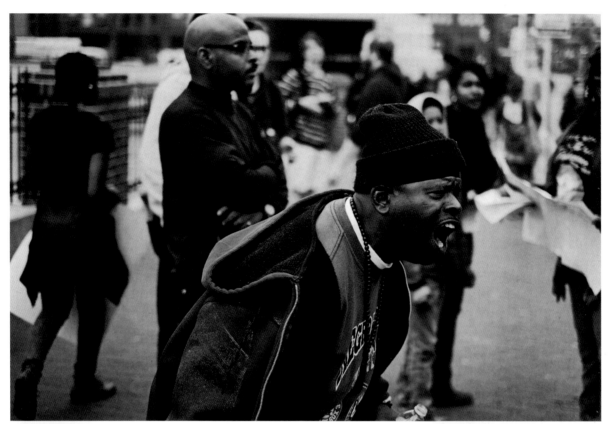

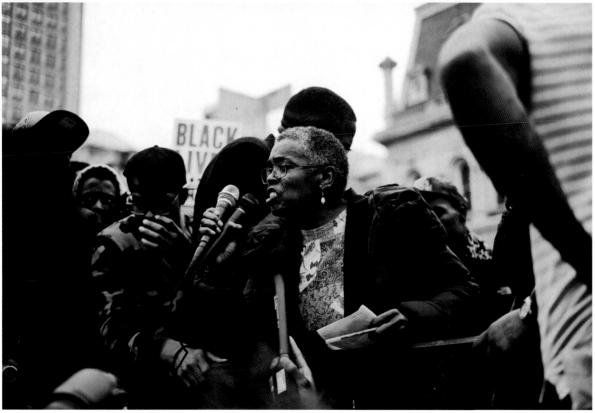

MORE FOR OUR MONEY: BUSINESS IN THE AGE OF SOCIAL CHANGE

Jamira Burley

In recent years the uber-rich elite in business and tech industries have morphed into real-life anti-villains. Celebrity philanthropy has steadily progressed into a group of wealthy gatekeepers. According to Giving USA, companies donated $18.55 billion to charity in 2016, with frequent intent to improve public image, which can, in turn, improve profitability. But what are the consequences for communities when companies use charity to mask their growing pockets and shrinking taxes? Where is the accountability for such a savior complex, especially after moments of uprising?

In the wake of the 2020 police killings of Breonna Taylor and George Floyd, we have seen an explosion of corporate dollars entering the social justice space. Too often, though, in conversations that determine the most beneficial investments, these corporations leave out the very communities they aim to help. The vast majority of work addressing social issues largely falls on the backs of those in impacted communities. It is those with firsthand experience who are expected to step up and tirelessly charge the policy makers to fulfill their elected purpose of serving the needs of the community.

As we move into this new era of activism that includes corporate social responsibility, we must explore the role businesses can and should play in addressing the needs of their consumers and employees. What can leaders and professionals do to forge new partner-

ships with built-in accountability mechanisms for social change at the government and corporate levels? In my career, I have worked at the intersection of community, policy, and social impact. My work seeks to cultivate a sense of responsibility in a wide community of stakeholders who have a vested interest in the state of the world. My work relies on meaningful engagements that prioritize consumers' needs, with a focus on actionable and sustainable change.

With the increased division and social unrest around the world, we have a deep understanding that money alone, without the political will and the policies to back it up, will not fix the systemic inequalities holding us all hostage. Already, we see everyday Americans utilizing social media to hold businesses accountable and push for overhauls of policies, practices, and leadership.

Similar to the widespread boycotts of the mid-twentieth century, everyday Americans are rising and creating a business community that demands dignity in exchange for their dollar. For Millennials, and now Gen Zers, there are higher expectations for businesses to uphold ethical standards that improve the human experience. For these buyers, the transaction goes beyond profit—their dollar signifies their endorsement. As a result, many are turning toward supporting small businesses and entering the area themselves.

Let's be clear: the people will not be blinded by a check. Like many young people, I started my activism out of necessity. For me and those who come from a similar background, the paper trail of corporate donations can be one that determines life or death. Which is why the need for continued community engagement has to be at the center of change. There is a real need for a collective impact strategy, a framework that allows everyone to play a role, whether as an activist, a conscious buyer, or a budding entrepreneur. Everyone has a role to play to shift the balance of power.

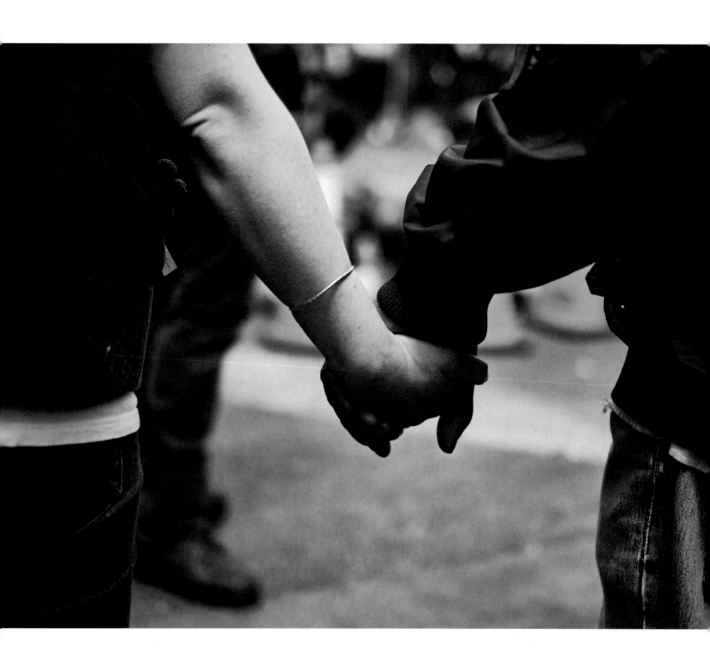

"PEOPLE SAY YOU FIGHT FIRE BEST WITH FIRE, BUT WE SAY, YOU PUT FIRE OUT BEST WITH WATER. WE SAY, YOU DON'T FIGHT RACISM WITH RACISM. WE'RE GONNA FIGHT RACISM WITH SOLIDARITY."

—FRED HAMPTON

FREDERICK DOUGLASS: HOW WE FOUND OUR FREEDOM

Chris Wilson

At the age of seventeen, I was sentenced to natural life in prison.

The first few years of incarceration were a blur of numbness and disbelief. At a time when the average American teenager was gearing up to make the most important decisions of their life, writing college essays and deciding on career paths, my whole life had been mapped out for me along the corridors of prison.

I sought and found freedom in the prison library. That was where I first encountered Frederick Douglass in a photo. At first glance, I liked his style: the three-piece suit, his perfectly groomed beard, his wild, woolly hair, the piercing intellect in his eyes, and the fact that he never smiled, because his people were not yet free. His countenance was resistance. I liked that. And, given the fact that I was serving a life sentence, I needed that.

I read everything I could get my hands on in the prison's meager library. One story from Douglass's autobiography struck me like a lightning bolt. When he was still enslaved in Maryland, Douglass struck up a friendship with his enslaver's wife. They maintained a warm rapport, despite Douglass's legal status as her property. She saw Douglass's talent and intellect and took him under her wing by teaching him to read. They held lessons for several weeks without interruption until Douglass's owner caught them in the act.

He shut it down immediately. He lectured his

wife in front of Douglass, asserting that teaching Douglass to read would "ruin" him: "There will be no keeping him. . . . [Teaching him to read] would forever unfit him for the duties of a slave." Douglass's enslaver did not know that he was teaching Douglass the most important lesson of his life: bondage is real, but it starts and ends with the mind.

If Douglass could free his mind, he could, perhaps, learn to free himself from slavery. White slave owners understood that knowledge is power. It is the reason why enslaved people faced overtly harsh penalties for pursuing the most basic forms of literacy. Once Douglass realized the power of education, there was no turning back. Douglass pursued his education "by any means necessary," going so far as to trade bread with white children in exchange for reading lessons. That simple act could have gotten him lynched in nineteenth-century America. Risky business.

Our modern-day fight for freedom parallels the struggles of Douglass's era with painful clarity. The "school-to-prison" pipeline denies Black and brown communities quality education and a safe and healthy learning environment. Many of the schools that we do have, in fact, resemble prisons themselves: an emphasis on compliance, harsh punishments that land on Black students in particular, and a heightened sense of right and wrong. It is no accident that many Black students can start out at in-school suspension and end up incarcerated. The high school dropout who winds up in prison is not just a Hollywood cliché; their experience is an empirical and emphatic truth, and it is exactly what happened to me. I was one of the 80 percent of inmates who do not have a high school diploma at the time of incarceration.

As I relived Douglass's epiphany, I experienced my own. The fact that education is so powerful indicts a system that is designed to oppress through gatekeeping access to knowledge. Black people have had to fight for our education, our knowledge, and our history for centuries. That system of oppression extends into the modern criminal justice system and the disenfranchised communities that populate it. Because our educational prospects were stunted, thousands of people who would otherwise be contributing members of society were funneled into modern captivity, forced again to fend for ourselves. Education is not just prevention; it is a cure for a system suffering from a centuries-old plague.

I started my own educational journey in earnest. I spent hours in the prison library. I consumed every book I could put my hands on, sharpening my intellect and acquiring new skills. I learned everything from chess to computer programming, which I practiced by writing code longform on a yellow notepad. Over the span of nearly twenty years incarcerated, I traveled the world, transporting myself to Italy, China, Colombia, and South Africa through my reading. I got my GED, went to college and graduated, learned several languages, and became an entrepreneur. Above all, I learned the inner workings of the criminal justice system and how to advocate for my freedom. My body was confined to a cell, but my mind was not. And after years of relentless and focused self-cultivation, just shy of twenty years in prison, I was granted my freedom.

Douglass's story is not that of a hero; his life was not the work of one man. Rather, Douglass had a substantial support system. His wife financed his freedom and supported his education. Through his travels across Ireland and a lot of Europe, he encountered leaders and thinkers who deepened his understanding of human rights. Those friendships made him more expansive and powerful as a leader. This village of supporters, confidants, and advocates is what Martin Luther King Jr. would later call the Beloved Community.

Like Douglass, once free, I made up for lost time. I returned to my community in DC and built companies to give returning citizens like me a second, third, and fourth chance. Today, I labor alongside my community as we try to make the world a better, fairer place. Frederick Douglass's critical leadership in the effort to abolish slavery continues to bolster movements for justice. Had I not seen that photo of Douglass, I may not have achieved my freedom and become an entrepreneur and author. To this day, images that chart our history remain engines of empathy, change, and inspiration for our Beloved Community. And we, the Beloved Community, are the village we need to achieve and sustain our individual and collective pursuit of freedom.

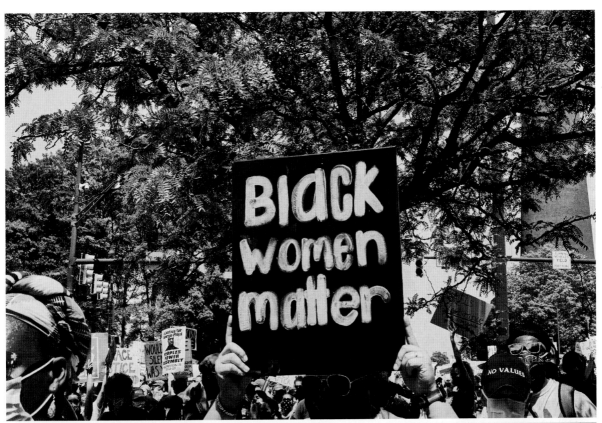

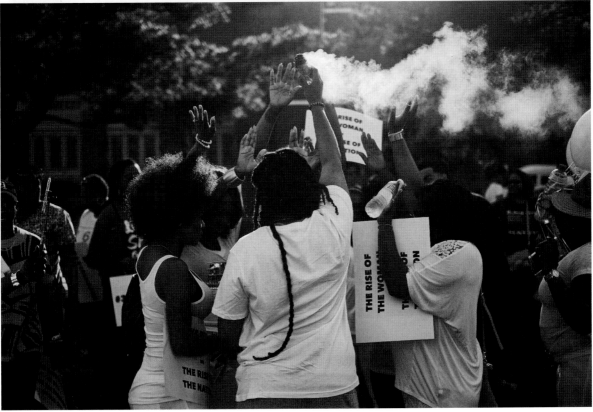

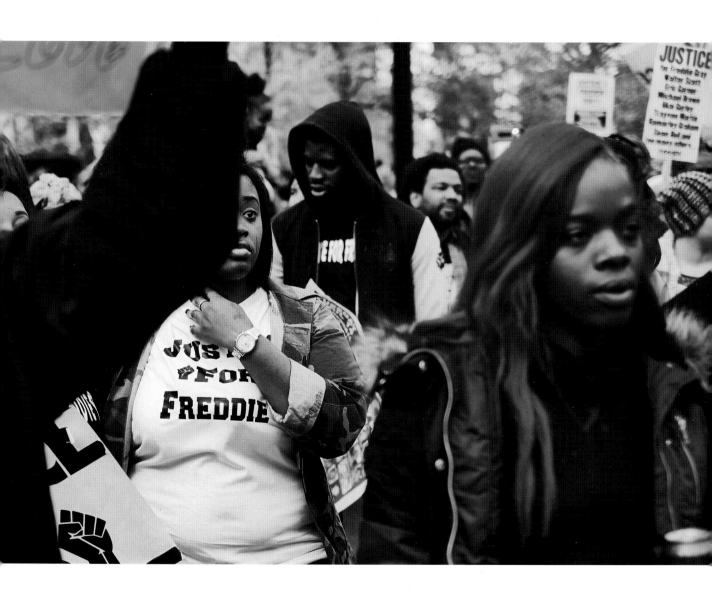

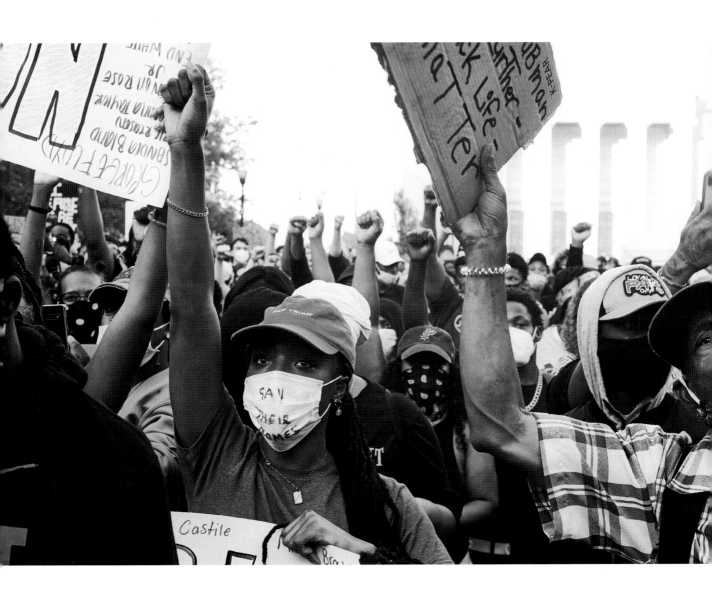

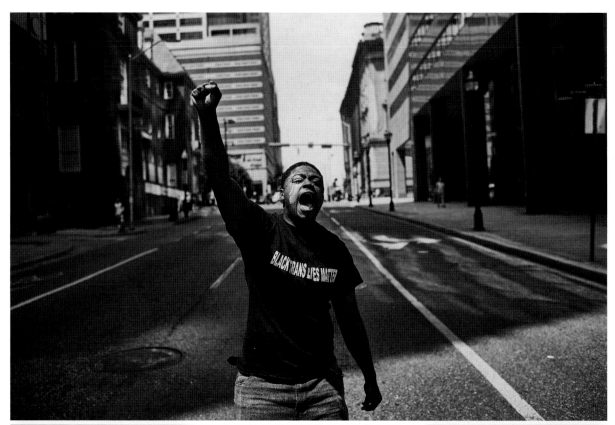

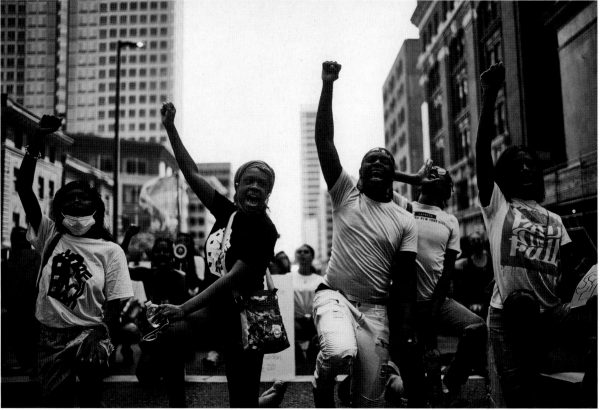

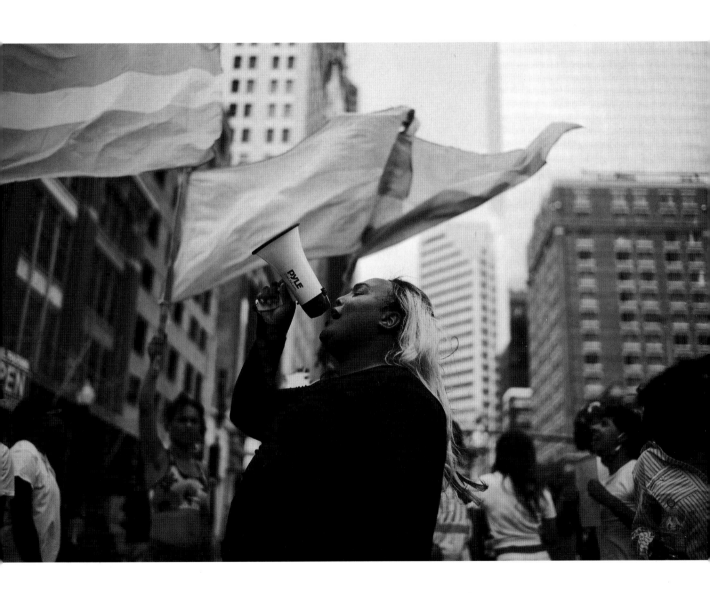

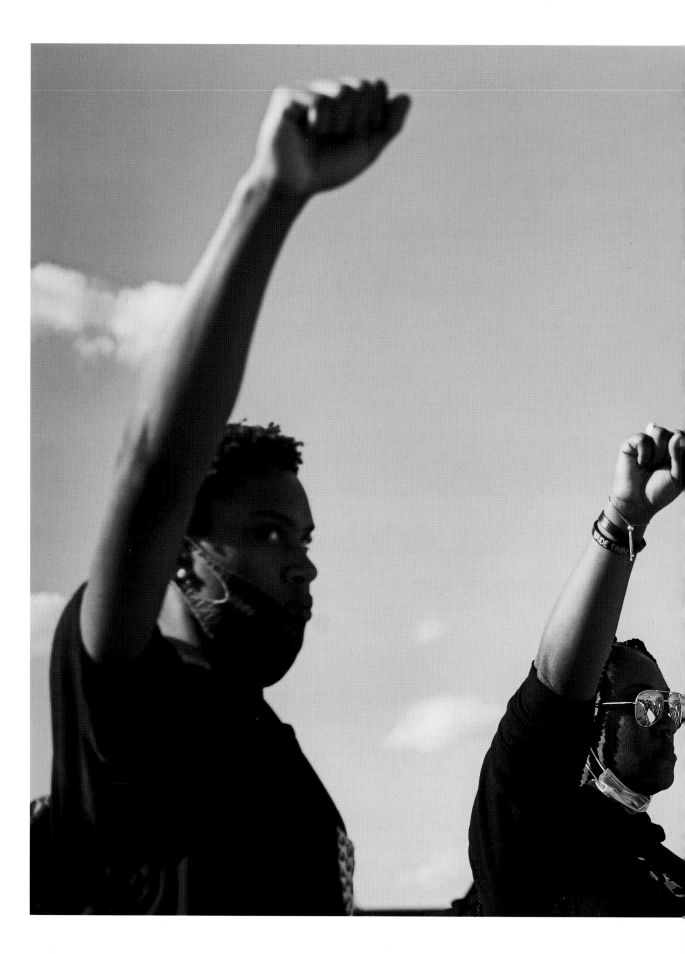

"WE MAY ENCOUNTER MANY DEFEATS, BUT WE MUST NOT BE DEFEATED."

——MAYA ANGELOU

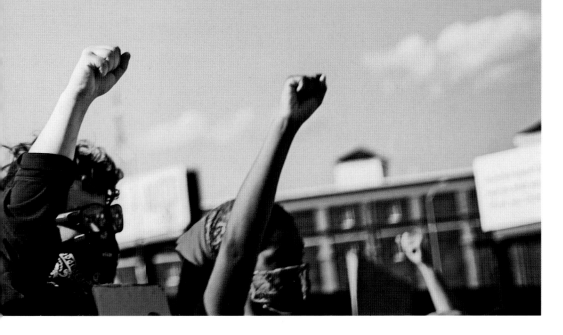

The Day the Pens Broke (for Mama Morrison)

Tariq Touré

You saw a levee pooled with all we wish to say
And pressed your heel into the cracks we all noticed
The letters, words, sentences you trained as assassins
Struck in the dead of countless nights

To the woman who caressed & marauded consciences
Belted an era in the passenger seat of its own gorgeous & ugly
Heaved plum-bodied babies into the rhythm of their glory
Name a thumb greener, more endowed to learn us love
Did we not bathe in your ink, swim in your stories, drown in your truth?
Ain't there still caves to be canvassed in the mountains you left?
Say, On the day the pens broke, we dare not to own the one
Who taught us to find freedom in owning ourselves

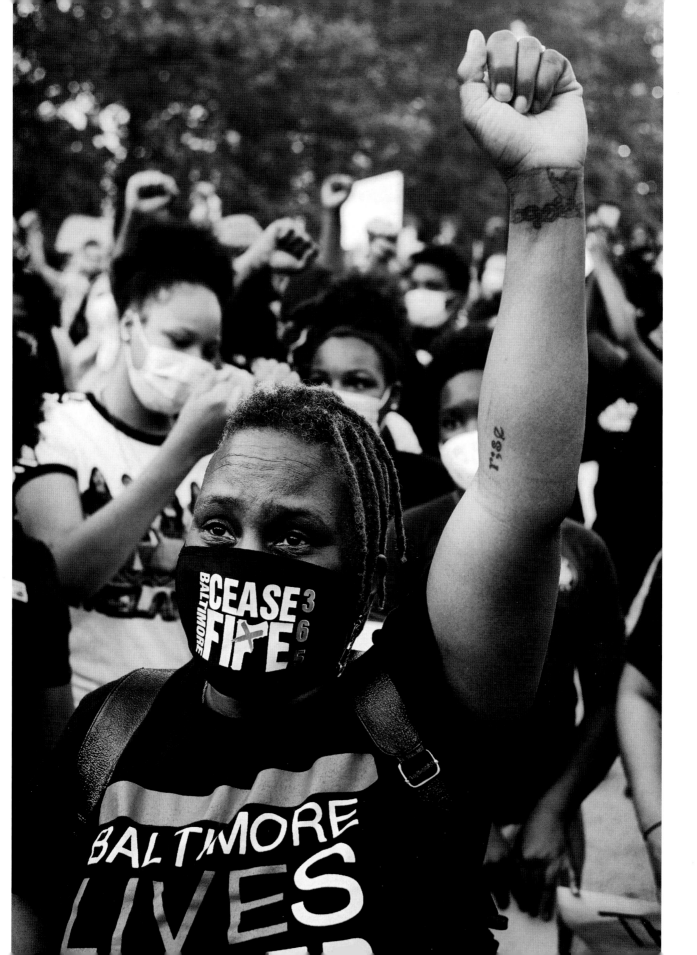

SELF-CARE: A NEW REVOLUTION

Tiffany Loftin

Activism of the last ten years has focused first on accountability, then on destroying systems and ideas and rebuilding a new society. That means we focus on every sector where injustice takes place—in policy, in culture, in classrooms, and on the streets. And while we spend much of our lives advocating against these systems that were built to keep us from thriving, we also carry an individual responsibility to model collective community, trust, and safety in our organizations, neighborhoods, and personal relationships.

In my early years of social justice work, I borrowed from Black Panther leader Huey P. Newton's *Revolutionary Suicide*. The framework offers two options: you can let the systems set up to kill us succeed, or you can fight them, knowing that you may die in the process. That

way, if you succumb to the violence of racism, it will not be without a fight. I was once there, ready to die for my people at all costs and earn a badge of honor. Even before my time as an activist, the world weighed heavily on me. When I was sixteen, I attempted suicide twice, depressed because of family tension and the pressure of the world that was waiting for me as a young Black girl. Now I am proud to call myself a survivor. Young people who are trying to look up to us and leaders before us see that our leaders are in exile, our leaders are still imprisoned, our leaders are not alive. And we would much rather have those leaders here with us, still working, still living, fighting, instead of in exile, imprisoned, or gone prematurely from the grave effects of stress.

Unfortunately, Newton's prophecy has come

true, and we have lost martyrs—friends who did not finish with us because they could no longer bear the burden of fighting for global change.

I learned from Jessica Byrd, who's an incredible Black queer feminist and political strategist, that we have to lead our people from a place of abundance, not a deficient mindset. Longtime activist Ash-Lee Henderson also taught me that we can always create new knowledge together. Together, their teachings have afforded me a new and important lesson: that self-care is its own kind of freedom. By taking the time to know myself, I am a better activist. I realized that I was organizing tirelessly in a reactionary way, focused on what we as a people didn't want and what we shouldn't have to deal with, what should stop killing us, and what we demanded society get rid of. I struggled to articulate clearly what we wanted to replace this injustice with, what we were actually fighting for.

Thriving in the face of a system that is telling you you're not supposed to thrive is part of our work, too. There should never be a Black person in this country who feels guilty for taking care of themselves or for enjoying their life. Now I take time to travel, I rest, and I make time for my friends and enjoy the experiences and luxuries that the generations before us already won. And I continue to remind those doing this work that everyone needs a vacation! Everyone deserves to check in, check out, and be checked up on. It is not up to us to earn rest—this mindset leads to premature burnout.

The pursuit of justice for Black people, victims of police brutality, those in need of safe abortions, those lost to COVID-19, those with mountains of student loan debt due to the high cost of education, and those experiencing voter suppression is one that leaves us with a deficit of time, energy, and spirit. When we include hope and rejuvenation in our liberation paradigm, we as organizers are creating space for people not only to dream of freedom, but to live it as well. Modeling my strength doesn't just happen when I am in the streets of DC demanding voting rights, in the sands of Palestine demanding freedom, or in the streets of Louisville saying Breonna Taylor's name. My strength shows when I post an early workout with my friends on Instagram, when I am skydiving through open air over Dubai, and when my toes are deep in the sands of Miami beaches. Strength is both resisting injustice *and* indulging in the magic of the world.

There is a rebirth of joy and healthy lifestyles being inserted into liberation movements. We understand that this work is long-lasting and that we must advocate for others and take care of ourselves in equal amounts. We must take advantage of the privileges our present reality affords us to make up for the violent conditions of the past that did not provide space for rest and joy.

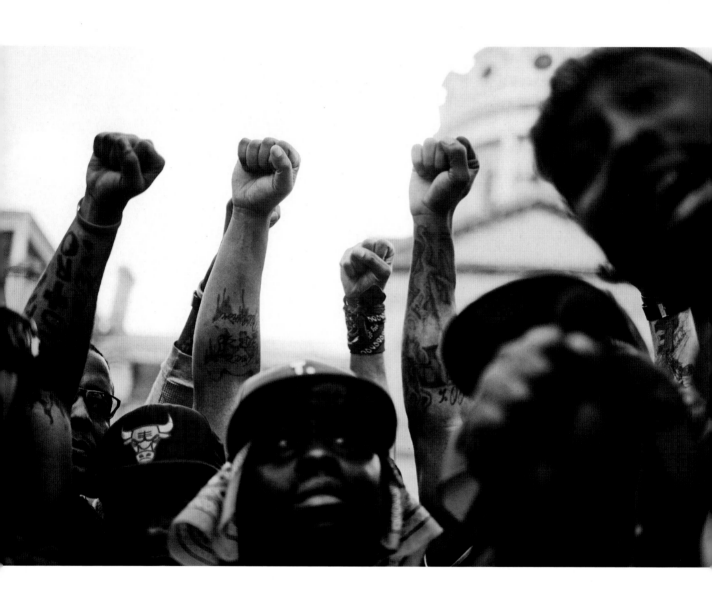

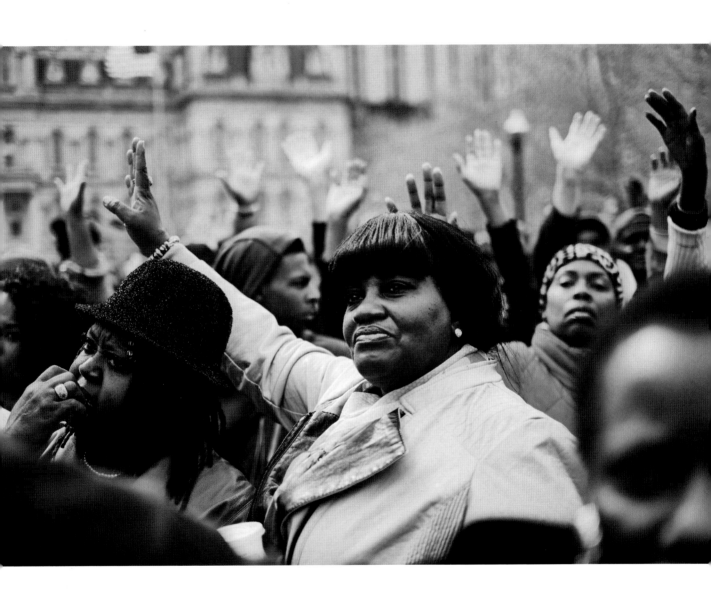

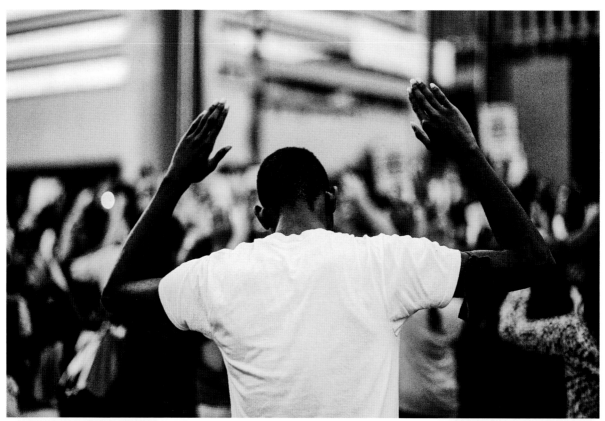

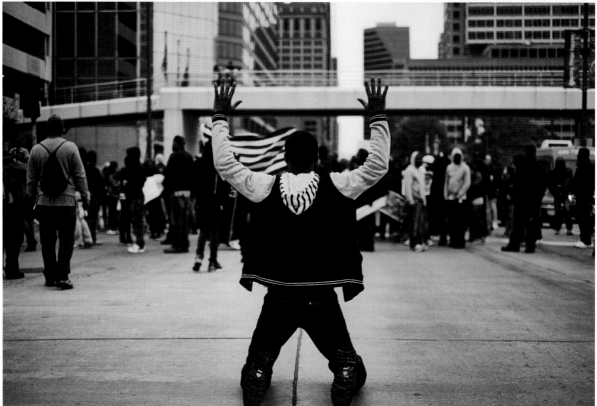

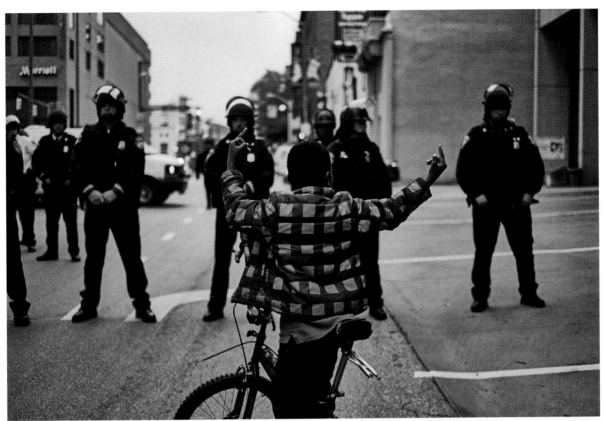

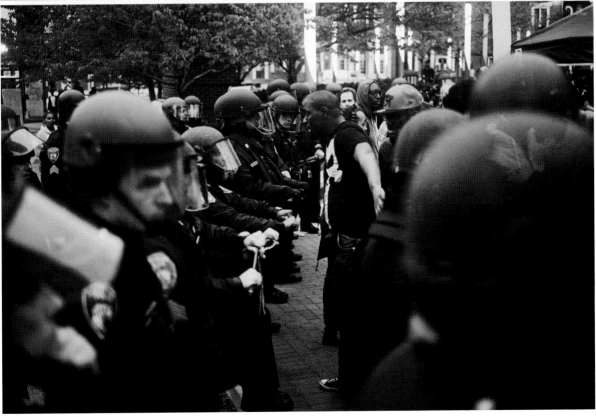

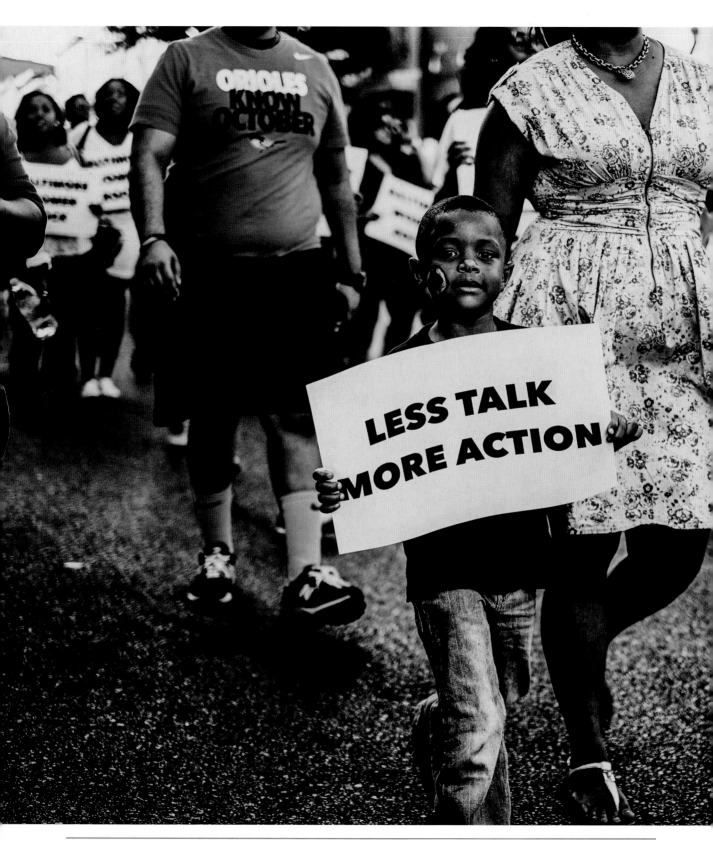

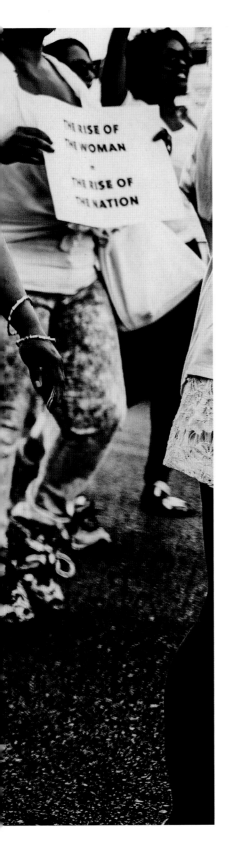

"NOT EVERYTHING THAT IS FACED CAN BE CHANGED; BUT NOTHING CAN BE CHANGED UNTIL IT IS FACED."

—JAMES BALDWIN

ACKNOWLEDGMENTS

First off, none of this would be possible without my family! My mother, Gail Allen, stepfather, Raynard, and baby sister, Sydney—I can't thank you all enough for all the love and support. My Golden Girls: my grandma Doris, Marget, Sharine, and my aunt Joan, thank you for always praying over me. My godmothers Debbie and Tracy and all my cousins, I love you all. My big homie D. Watkins, you made this book possible. Thank you for constantly pushing me and raising the bar.

Thank you to the entire *No Justice, No Peace* crew for all the hard work: Adrienne Ingrum, Brea Baker, Johanna Castillo, Krishan Trotman, and Amina Iro. Kondwani Fidel, Wallace Lane, DeRay Mckesson, Chris Wilson, Tariq Touré, and Lawrence Burney, I appreciate y'all! Thank you, Peter Kunhardt and the Gordon Parks Foundation, for the continued support. And thank you to Kiran Karnani and the entire Leica Camera USA team who gave me the tools to create.

ABOUT DEVIN ALLEN AND GORDON PARKS

DEVIN ALLEN is a self-taught artist, born and raised in West Baltimore. He gained national attention when his photograph of the Baltimore Uprising was published on the cover of *Time* magazine in May 2015—only the third time the work of an amateur photographer had been featured. Five years later, after the deaths of George Floyd, Tony McDade, and Breonna Taylor, his photograph from a Black Trans Lives Matter protest was published on the cover of *Time* magazine. He was the inaugural recipient of the Gordon Parks Foundation Fellowship. In 2017, he was nominated for an NAACP Image Award as a debut author for his book *A Beautiful Ghetto*.

His photographs have been published in *New York* magazine, the *New York Times*, the *Washington Post*, and *Aperture* and are also in the permanent collections of the National Museum of African American History and Culture in Washington, DC, the Reginald F. Lewis Museum in Baltimore, and the Studio Museum in Harlem.

He is the founder of Through Their Eyes, a youth photography educational program, and the recipient of an award for dynamic leadership in the arts and activism from the Maryland Commission on African American History and Culture. He lives in Baltimore.

GORDON PARKS, AMERICAN (1912–2006)

In a career that spanned more than fifty years, photographer, filmmaker, musician, and author Gordon Parks created an iconic body of work that made him one of the most influential artists of the twentieth century. Beginning in the 1940s, he documented American life and culture with a focus on social justice, race relations, the civil rights movement, and the African American experience. Born into poverty and segregation in Fort Scott, Kansas, Parks was drawn to photography as a young man. Despite his lack of professional training, he won a Julius Rosenwald Fellowship in 1942; this led to a position with the photography section of the Farm Security Administration (FSA) in Washington, DC, and, later, the Office of War Information (OWI). By the mid-1940s, he was working as a freelance photographer for publications such as *Vogue*, *Glamour*, and *Ebony*. Parks was hired in 1948 as a staff photographer for *Life* magazine, where for more than two decades he created some of his most groundbreaking work. In 1969 he became the first African American to write and direct a major feature film, *The Learning Tree*, based on his semiautobiographical novel. His next directorial endeavor, *Shaft* (1971), helped define a genre then referred to as Blaxploitation films. Parks continued photographing, publishing, and composing until his death in 2006.

ABOUT THE CONTRIBUTORS

ANGELO PINTO is a movement lawyer, senior strategist, and policy guru who has contributed to the Indigenous Peoples March, the Free Meek Mill Campaign, the Restore Heat Campaign at MDC Brooklyn, the Raise the Age Campaign at the Correctional Association of New York; co-founded Until Freedom; and is a founding member of Justice League NYC.

ASHLEY MONTERROSA is the youngest sister of Sean Monterrosa. She turned twenty the day after her brother was killed. She carries on her brother's legacy and as a social justice warrior received the Gathering for Justice's Troublemakers for Liberation fellowship.

BREA BAKER is a writer and freedom fighter who has been working on the front lines for almost a decade, first as a student activist and now as a national and global strategist. In that time, she has contributed to dozens of electoral and advocacy campaigns, including the 2017 Women's March (where she served as the youngest national organizer), the 2018 student walkouts against gun violence, and Jumaane Williams's successful bid for New York City public advocate. In addition, Brea advises storytellers and industry leaders on making content that builds our collective imagination.

CARMEN PEREZ, a Chicana feminist, is the president and CEO of the Gathering for Justice, a nonprofit founded by Harry Belafonte dedicated to ending child incarceration and eliminating racial disparities in the criminal justice system. She was one of four national co-chairs of the 2017 Women's March.

CHARLENE A. CARRUTHERS is a writer, filmmaker, and PhD student in the Department of African American Studies at Northwestern University. She is the founding national director of Black Youth Project 100 (BYP100).

CHRIS WILSON is the owner and founder of the Barclay Investment Corporation and author of *The Master Plan: My Journey from Life in Prison to a Life of Purpose*.

CLINT SMITH is a staff writer at the *Atlantic.* He is the author of the *New York Times* bestseller *How the Word Is Passed* and *Counting Descent*.

D. WATKINS is the editor-at-large of Salon.com and the *New York Times* bestselling author of *Black Boy Smile*, *We Speak for Ourselves*, *The Beast Side*, and *The Cook Up*. He is a professor at the University of Baltimore.

DARNELL L. MOORE is director of inclusion strategy for content and marketing at Netflix and the former head of strategy and programs (US) for Breakthrough TV. Along with former NFL player Wade Davis II, he co-founded YOU Belong, a social-good company focused on the development of diversity initiatives.

DERAY MCKESSON is a civil rights activist, podcaster, and former school administrator. Author of *On the Other Side of Freedom: The Case for Hope*, he is among those who launched Campaign Zero, a policy platform to end police violence.

DOMINIQUE CHRISTINA is an educator and activist who holds five national poetry slam titles. She is a writer and an actor for the HBO series *High Maintenance*.

EMMANUEL ACHO is host and producer of *Uncomfortable Conversations with a Black Man*, an online series that aims to drive meaningful dialogue around race.

GAIL ALLEN is the mother of Devin Allen.

JACQUELINE WOODSON is the National Book Award winning and *New York Times* bestselling author of *Red at the Bone*. She is a MacArthur Fellow and has authored over forty bestselling and award-winning books.

JAMEL SHABAZZ is known for his photographs of New York during the 1980s. A documentary, fashion, and street photographer, he has authored ten monographs. His photographs have been exhibited worldwide and his work is housed within the permanent collections of the Whitney Museum, the Studio Museum in Harlem, the Bronx Museum, and the Smithsonian's National Museum of African American History and Culture. Over the years, Shabazz has taught young students at the Studio Museum in Harlem's "Expanding the Walls" project, and the Schomburg Center for Research in Black Culture's "Teen Curators" program. Jamel is the 2018 recipient of the Gordon Parks award for documentary photography, and a member of the photo collective Kamoinge.

JAMIRA BURLEY is on a mission to lead systemic and sustainable change that improves the lives of young people. She heads youth engagement for the Global Business Coalition for Education and formerly managed the gun violence and criminal justice portfolios at Amnesty International USA.

KEEANGA-YAMAHTTA TAYLOR, an activist for Black lives who pursued her higher education while working as a tenant advocate, is an assistant professor of African American studies at Princeton University and a MacArthur Genius Grant Fellow. She is author of *Race for Profit* and *From #BlackLivesMatter to Black Liberation*.

KONDWANI FIDEL, a poet and essayist from—and currently living in—Baltimore, has lectured and shared poetry at universities, conferences, and literary events across America and in London.

LAWRENCE BURNEY hails from Baltimore, hosts Red Bull Radio, and is senior editor at the *Fader*.

LESLÉ HONORÉ is a Blaxican poet who has been featured in the *New York Times*, the *Chicago Tribune*, and on WBEZ (NPR). She works to empower youth to find their voices through the arts and inspire people to stand in the gaps that social, economic, and racial inequities create.

MICHELLE MONTERROSA is the eldest sister of Sean Monterrosa. By putting her body on the line to bring justice and awareness to her brother's case nationally, she received the Gathering for Justice's Troublemakers for Liberation fellowship.

RUBY HAMAD is a freelance writer and PhD candidate in media studies and postcolonial studies at the University of New South Wales, where she is researching media criticism and coverage of Arabs and the Middle East. She is the author of *White Tears Brown Scars*.

TARIQ TOURÉ is a poet and native son of West Baltimore.

TIFFANY LOFTIN is a former student organizer who served as the president of the United States Student Association. She has since held leadership roles in the AFL-CIO and NAACP.

WALLACE LANE is a poet from Baltimore who teaches English and creative writing at Baltimore City Public Schools.

W.J. LOFTON, a poet, director, and songwriter centering his work on the intersections of Black queer identity, was selected by Ava DuVernay for a Law Enforcement Accountability Project (LEAP) grant, and his writing has been featured in *Time* and other magazines and at Sundance Film Festival.

CREDITS

JAN 1 9 2023